IMAGES
of America

GROVE CITY

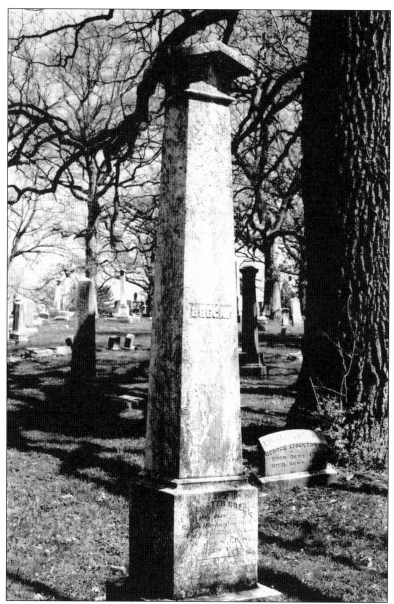

BRECK'S GRAVE. Grove City founder William Foster Breck was born on May 14, 1805, in Belpre. Little is known of his early years, but in 1846, he purchased over 15 acres of land from Hugh Grant Jr. for $120. In 1852, Breck, along with a commission, platted the land into lots. The village of Grove City was born. Breck died in a freak accident in 1864, two years before the village was officially incorporated. Breck and his wife, Elizabeth, are buried in Greenlawn Cemetery in Columbus.

On the cover: **RACING AT BEULAH PARK.** Beulah Park was originally developed in 1895 as grounds for family outings, speeches, and revivals in a rustic, wooded setting. In 1898, a half-mile racetrack was added as a county fair attraction, and in 1923, the setting grew into Ohio's first Thoroughbred racetrack. The "Sport of Kings" remains a Grove City attraction to this day. (Courtesy of Beulah Park.)

IMAGES
of America

GROVE CITY

Janet Shailer and Laura Lanese

ARCADIA
PUBLISHING

Published by Arcadia Publishing
Charleston SC, Chicago IL, Portsmouth NH, San Francisco CA

Printed in the United States of America

Library of Congress Catalog Card Number: 2008931400

For all general information contact Arcadia Publishing at:
Telephone 843-853-2070
Fax 843-853-0044
E-mail sales@arcadiapublishing.com
For customer service and orders:
Toll-Free 1-888-313-2665

Visit us on the Internet at www.arcadiapublishing.com

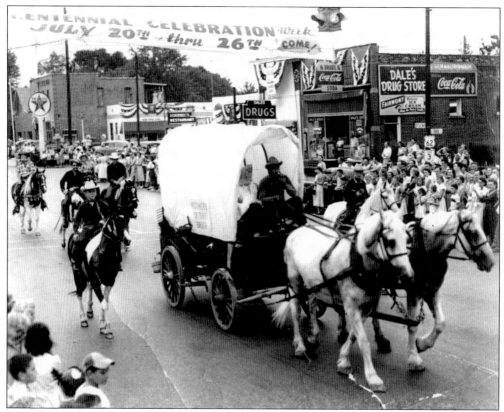

GROVE CITY'S CENTENNIAL. In 1952, Grove City held a weeklong celebration to hail its 100th anniversary. Among the events was a parade featuring the reenactment of early settlers moving into the wilderness territory that would grow into their thriving town. Driving the horse and wagon are Martha and Bob Geyer. Among those riding horses behind the wagon are Dick Reed, Harley Haag, and Larry Thomas.

CONTENTS

ACKNOWLEDGMENTS

This book is dedicated to all the people in the past, present, and future of Grove City. This publication could not have been written without the assistance and support of the Southwest Franklin County Historical Society and the reference department of the Grove City Library, specifically Bethanne Gibboney Johnson and Karen Lane, who were invaluable to this effort. Others who were particularly helpful were Marilyn Gibboney, Earl Nicholson, and Meg Scott. We are grateful to Ruth Sawyer Jividen, who is the last direct descendant of Hugh Grant Sr. and his wife, Catharine Barr.

We would also like to thank the following people who contributed to this book: Leona Gustafson, Barbara and Roy Grossman, Stanley and Mary Jane Keller Norris, Paul Grossman, Sharon Thomas Downs, Don Washburn, Edwin Smith, Betty Evans, Marcella Hickman, Bill Cain, Jack and Betty Seese, Shirley White Bartok, Brenda Todd Steinhoff, Louis and Joan Eyerman, Steve Jackson, Linda Lewis, Jack McClure, Sue Ruoff Zeszotek, Virginia Haines, Dick Neff, Betty Ranke Breckenridge, David Lane, Cheryl Grossman, Ken and Gary Milligan, Ray Ruoff, Bob and Lois Brofford, Ruth Ranke, Bill Lotz, Judy Hoover, Jason Shamblin, Jessica Hamlin of Beulah Park, and the staff at the Columbus Metropolitan Library, the *Grove City Record*, and the *Southwest Messenger*.

We want to acknowledge the work of the late Harold Windsor and the late Faye White Morland.

Unless otherwise marked, all photographs are part of the Southwest Franklin County Historical Society archives. We have tried to capture the essence of the area from 1803 to Grove City's centennial year of 1952. We apologize for any errors or omissions.

Lastly we want to thank our families for their support and patience. Coauthor Janet Shailer would like to thank her husband, John, son and daughter-in-law John (Jay) and Allison, daughter Annie, and grandson Alexander. Coauthor Laura Lanese would like to thank her husband, Mike, and her three children, Michael, Camille, and Francesca.

INTRODUCTION

Grove City can trace its beginnings to land grants conferred upon Revolutionary War heroes Gen. Daniel Morgan and Col. William Washington. In 1803, Hugh Grant Sr., Grove City's first settler, brought his wife, Catherine, to the region from Pittsburgh. Grant operated a gristmill in Pittsburgh and routinely loaded his excess goods on a raft and sailed down the Ohio and Mississippi Rivers, where he sold the goods in New Orleans. On his return trip, he walked the distance between the Gulf of Mexico to Pittsburgh. Presumably on one of these trips, he detoured into central Ohio and fell in love with the Scioto Valley region. He sold his land in Pittsburgh and moved to the area that would become Grove City and began farming. Grant did not live long enough to see the fruits of his labor. He was killed when he fell out of a tree trying to dislodge a beehive. Grant had settled on the wrong property, and after his death his widow and children relocated to their rightful homestead, which is located on Haughn Road and Park Street. His last direct descendant still lives on this property.

For several years after Grant's arrival, a handful of other settlers followed him to the area. Grove City's growth in the early 19th century was hindered by its isolation from the rest of the region. All of this changed with the development of the Columbus and Harrisburg Turnpike in 1848, which placed the handful of homes in the area alongside this major thoroughfare leading to the state capital. In 1846, William Breck visited the area looking to buy a farm. Instead he recognized the potential in the region, and he set about building a village. He purchased approximately 15 acres from Grant's son for $120. Breck and his associates platted this land for a village. He also bought another 300 acres west of Broadway, on which he established his farm. Breck's two associates George Weygandt and William Sibray were integral to building the village. Weygandt was a carpenter, and Sibray was a mason and plasterer. Breck's third associate was his brother-in-law, who died shortly after the purchase of the land.

After clearing the land, the town founders named the city for the beautiful grove of trees they left standing. Breck placed an advertisement in a Columbus paper to entice settlers, especially those with practical skills, to the village. He opened the first general store, started the first post office, and established a brick plant and a sawmill to facilitate the building of the community. Unfortunately, like Hugh Grant Sr., Breck was killed in a freak accident in 1864 when he fell off his horse. He did not live long enough to see the fruits of his labor, when in 1866, the village was incorporated with 37 residents.

While the Columbus and Harrisburg Turnpike was a catalyst for the small community, the village began to flourish with the arrival of the railroad and the interurban. In 1891, commuter service was first offered to Grove City residents by the Midland Company railroad. In 1895,

A. G. Grant, Hugh Grant Sr.'s grandson, developed the community's first subdivision, the Beulah Addition, named after his daughter. He then organized the interurban electric train, which provided more convenient commuter service than the railroad and directly serviced his newly built subdivision. A. G. successfully enticed Columbus commuters looking for low-cost housing stock and access to jobs in the capital city to move to the area. Ironically many of the homes were bought by employees of the Columbus Buggy Factory, who took the electric railway to Columbus to build horse-drawn buggies.

In addition to attracting commuters, Grove City had been attracting another significant group—German settlers. Most of the original settlers came from the East Coast states of Maryland, Pennsylvania, and Virginia, while a few came directly from Ireland. However, it was the German settlers, both first and later generations, who arrived in large numbers and left a lasting imprint on the village that can still be seen today.

The previous Grove City generations built several early churches, a few of which still stand today. The spire of the magnificent St. John's Evangelical Lutheran Church, built in 1889, still graces Grove City's skyline. The early settlers, also realizing the value of education, started subscription schools long before the state mandated public education. The children studied in log cabins and literally walked two miles to attend school. The town had one of the earliest high schools in the area, and its first graduating class was all women. The school system grew rapidly and is now part of the sixth-largest district in the state.

Grove City residents also created a vibrant downtown community that was filled with grocery and hardware stores, gristmills and sawmills, tile and brick factories, and a tavern or two. They also enjoyed various forms of simple entertainment, such as ice skating on the gristmill pond and participating in an assortment of social organizations. They flocked to the first Thoroughbred horse track, not only to place their bets but to socialize with their neighbors and to meet many of the out-of-town visitors who came to "play the ponies" at Beulah Park.

When their country called them to duty, Grove City citizens did not hesitate. They served in every major war the United States fought from the Revolutionary War to the current war in Iraq. Their dedication to duty ran deep. Fathers fought in one war, and sons fought in the next. One grandfather, Jonas Orders, helped defeat Blue Jacket at Fallen Timbers, while the grandson, Jonas Orders II, helped defeat the Confederates at Chickamauga. In the Civil War alone, almost 250 men from the lightly populated township answered Pres. Abraham Lincoln's call to preserve the Union and defeat slavery. The commitment to country continued throughout the 20th and 21st centuries, and Grove City's veterans received some of the nation's highest honors. A grateful community has humbly tried to honor them with parades, tributes, and memorials.

One of Grove City's biggest assets now is its location. It is situated within a 10-minute drive to Columbus, the state capital and the 16th-largest city in the United States. It is also located between two of the most important interstate highway systems in the country, Interstate 71 and Interstate 70. Placed within a few miles of the intersection of these two important highways, Grove City has become home to thousands of suburban commuters as well as to logistics and warehouse companies utilizing this strategic location.

A trip through Grove City today provides a mirror to its past. Hugh Grant Sr.'s original homestead, the grave site of Revolutionary War veteran John Hoover, the tall spire of St. John's Evangelical Lutheran Church—all serve as witness, not only to the settlers who came before us but to the significance the city places on its historical landmarks and to the people who built this wonderful community. We can only hope that this book does the same.

One

EARLY SETTLERS

In March 1803, Ohio officially became a state, and within two months, Franklin County was established. Around that same time, in the southwest corner of Franklin County, Hugh Grant Sr. and his wife, Catherine, settled in the region that would become Jackson Township and eventually Grove City. Others who followed on the heels of Grant were Nicholas Haughn, Samuel Breckenridge, John White, Samuel White, Joseph Hickman, William Duff, John Hoover, William Brown, Jonah Smith, and Henry Baumgartner. It took an exceptionally adventurous, rugged person to leave the comforts of home and relocate to the isolated and heavily forested Scioto Valley. Immediately upon arrival, these early pioneers had to clear the land, build their shelter, and plant their crops in very short order just to survive. Once they had established their farms, the pioneers organized church services and set up subscription schools. After they were settled in their spiritual and educational life, they shifted their focus to civic, social, and commercial issues.

By 1815, Jackson Township was carved out of the much larger Franklin Township. Residents named their new township after Andrew Jackson, who had recently defeated the British in the Battle of New Orleans. Other families who settled in the region before 1830 included the Seeds, the Millers, the Straders, the Borrors, the Gantzes, the Neffs, the Barbees, and the Shovers. Some, like the Seeds, had substantial property interests of up to 1,000 acres.

Given the isolated location of the settlement, Grove City's development was slow but steady. It was the organization of the Columbus and Harrisburg Turnpike in 1848 that spurred development in the region. The turnpike literally placed Grove City on the map between Harrisburg and the state capital. In 1852, the village's founder, William Breck, recognized the significance of this thoroughfare and platted the village. By 1852, Grove City's population was only about 50 people. Grove City became an incorporated village in 1866. The first village elections were held in May 1866, and Dr. Joseph Bullen was elected mayor with Randolph Higgy as clerk.

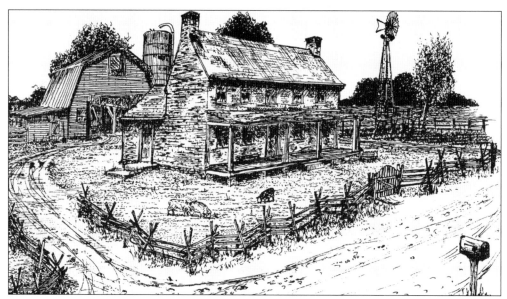

GRANT HOMESTEAD. This sketch depicts the 1840 Grant homestead, which still stands on Haughn Road. It is believed that the family first erected a log cabin on this property and in 1840 built the structure pictured here. The bricks for this home were made from clay found on the property. The home is now listed on the National Register of Historic Places. (Courtesy of Carl Green.)

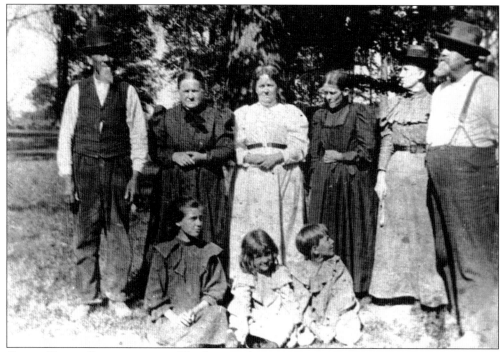

GRANT FAMILY REUNION, 1910. The Grant, Johnston, Higgy, Neiswender, and Thomas families are pictured here. Seen here are, from left to right, (first row) unidentified, Helen Johnston, and unidentified; (second row) Randolph Higgy, Catherine Grant Higgy, unidentified, Emma Grant Neiswender, unidentified, and R. D. Grant.

STAGECOACH STOP, C. 1884. This stagecoach stop is believed to be along Franklin Turnpike (State Route 104) close to Stringtown Road. The building is clearly marked "Grove City House" for travelers approaching from the south heading north to Columbus. Stagecoach stops, the forerunners of motels and rest stops, enabled travelers to recover and get a meal. They were also great places to disseminate both news and gossip.

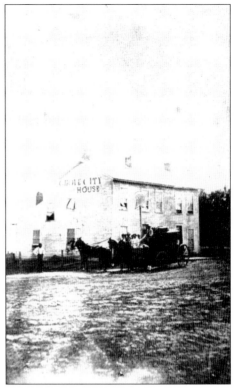

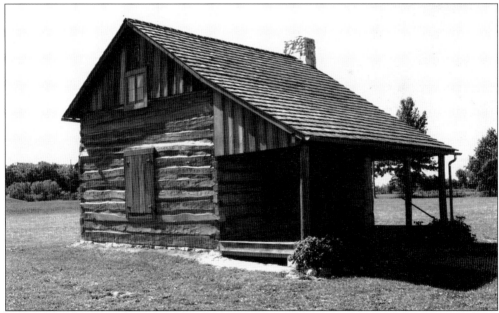

KIENTZ-KEGG HOUSE. This log house was built in the 1840s on Kegg Road (later Beatty Road) and eventually became the home of William Kegg. Kegg improved and added to the house. It was larger and more sophisticated than the earlier cabins in the area. The Kientzes purchased the cabin and later donated it to the Southwest Franklin County Historical Society and the City of Grove City in 1997.

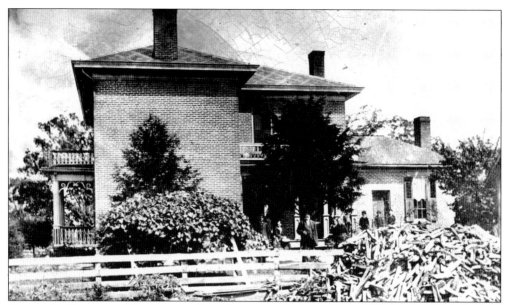

BORROR'S CORNERS. The first small settlement in Jackson Township was Borror's Corners, located at the intersection of today's State Routes 665 and 104 (at the time a good distance from Grove City). Magdalene Strader Borror and her seven children settled at this location around 1810. Soon a school, store, and several churches were built for the growing Borror families.

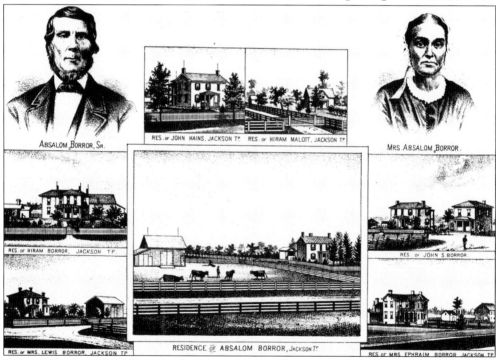

BORROR FAMILY, 1880. This sketch depicts Absalom Borror Sr. and his wife. Absalom was the son of Revolutionary War veteran Jacob Borror and his wife, Magdalene Strader. Around 1810, Absalom and his widowed mother moved to the area with his six siblings: Martin, Jacob, Myomi, Solomon, Christine, and Issac. (Courtesy of *History of Franklin and Pickaway Counties, Ohio.*)

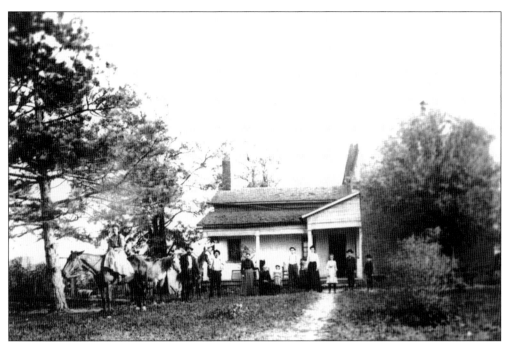

GANTZ FARM, 2255 HOME ROAD. Andrew Gantz, a native of Washington County, Pennsylvania, bought land in Jackson Township in 1817. The land was originally part of Col. William Washington's land grant, and Gantz bought it from Joseph Foos for $5 per acre. Parents of eight children, Gantz and his wife, Catherine, built this home in the 1830s. It is one of the oldest buildings in Grove City and is on the National Register of Historic Places.

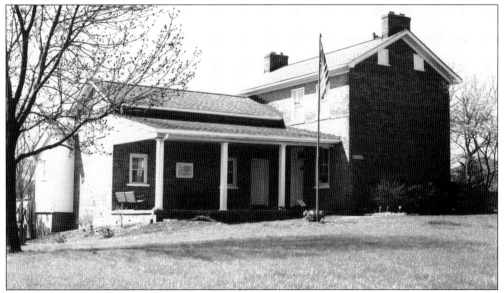

GANTZ FARMHOUSE TODAY. The Gantz Farmhouse and 20 acres of land were donated to the City of Grove City in the 1970s to be used as a park for city residents. The community held many fund-raisers, including several *maiwein* (May wine) festivals to help pay for the rehabilitation of the property. The property now includes an herb garden, arboretum, restored barn, walking trails, playground, and tennis courts.

Breck's Family Home, c. 1860. This house was the original home of Grove City founder William Breck and his wife, Elizabeth. The exact location is believed to have been on Columbus Street. William moved to the area in 1850 and platted the village in 1852. He did not live long enough to see the village incorporated in 1866.

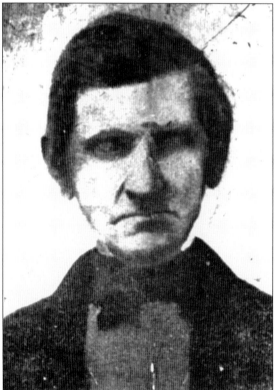

William Foster Breck (1806–1864). On August 8, 1864, William Breck was standing in a wagon when a horseman charged down Broad Street (Broadway) announcing Pres. Abraham Lincoln's renomination. Breck, a staunch Republican, responded with glee, but his horse bolted, thereby throwing him onto the street and killing him. His wife continued to live in Grove City before eventually moving to Pennsylvania.

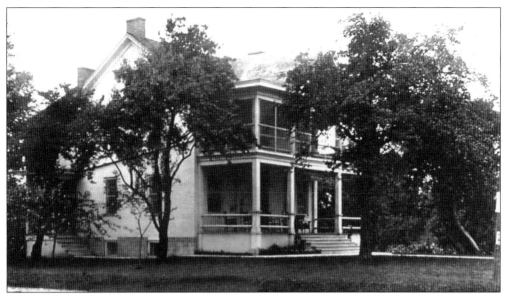

BRECK HOME–WOODLAND HOTEL, 4009 BROADWAY, C. 1900. This 20-room brick house was built for William Breck in 1864 and was not completed until after his death. The house was sold and eventually became the Woodland Hotel and later an old ladies' home. Located on the northwest corner of Broad Street (Broadway) and School Street (Park Street), the structure was torn down in the 1920s.

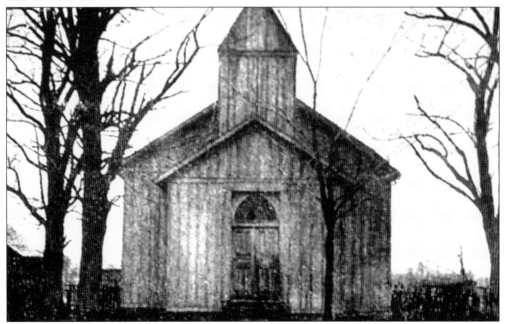

ORIGINAL ST. JOHN'S EVANGELICAL LUTHERAN CHURCH, 1853. The congregation of St. John's Evangelical Lutheran Church first met in the Highland Mission in 1849. In 1853, it built a wooden frame church on the northwest corner of Church Street (Columbus Street) and Arbutus Avenue. The Lutherans were divided between the new German immigrants, who could not speak English, and second-generation German Americans, who could not speak German. Services were held in German and English on alternating Sundays.

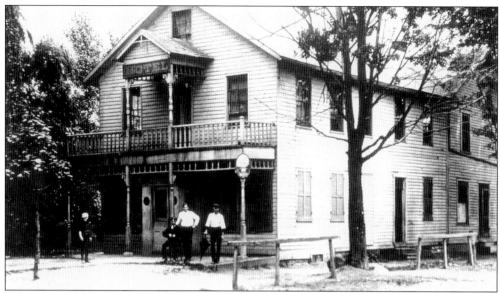

VOELKEL HOTEL AND BIERGARTEN, 1880. Carpenter George Weygandt built the Voelkel Hotel for William Blackburn in 1854 to accommodate stagecoach travelers between Mount Sterling and Columbus. In 1905, the tavern was purchased by Joseph Endres, the first of three generations of family who would own the business. It still contains the tiger-striped cherry bar installed in 1909 and today is known to locals as Plank's on Broadway.

TAX BILL, 1865. The tax bill for lots 51 and 52 on the original town plat belonged to Randolph Higgy, who moved here just as the town was being laid out by William Breck. Higgy served as the first village clerk. The houses on these lots are still standing on Columbus Street. Note the tax fees for half the year: 75¢ on one property and $1.93 on the other.

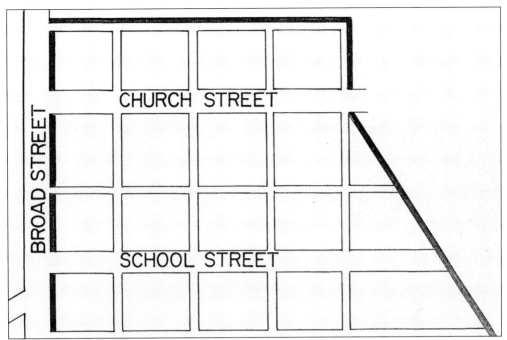

THE ORIGINAL 1852 PLAT. Stringtown Road and Grove City Road were originally the same road and ran diagonally through town. William Breck's first step in platting the town was to move Church (now Columbus) Street from a diagonal line to a horizontal one in order to make the intersections 90 degrees. (Courtesy of Earl Nicholson.)

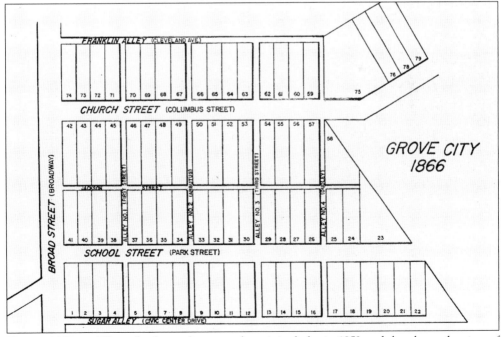

THE 1866 PLAT. The only change between the original plat in 1852 and the plat at the time of incorporation in 1866 was the addition of four lots on the northeast side of Columbus Street, where St. John's Evangelical Lutheran Church sits today. (Courtesy of Earl Nicholson.)

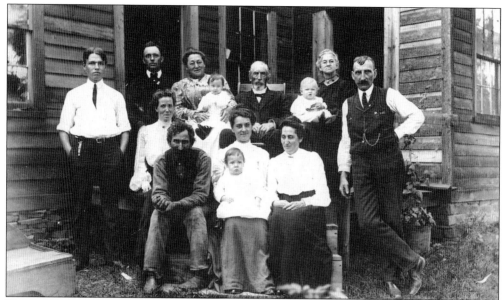

HOOVER FAMILY, C. 1900. After fighting in the Revolutionary War, John Hoover moved to Ohio. This photograph appears to be taken at the back of the original log cabin. Pictured here are John Hoover's descendants. They are, from left to right, (first row) George Hoover, an unidentified woman with a child, Sarah Hoover, and Dr. Lewis Hoover; (second row) Adah Hoover; (third row) unidentified, John Hoover (son) and wife Annie Alkire Hoover with an unidentified child, George Washington Hoover, and an unidentified woman with a child.

AMALIA FREDERICKA MILLER. Amalia Miller was the first female child born in the newly platted Grove City in 1853. The city fathers offered to give her parents two city lots in exchange for her to be named "City Belle." Her parents rejected the offer but accepted a dress for her instead. She married Jacob Voeller in 1873 and raised six children.

Two

GERMAN IMMIGRATION

Civil unrest spread across Europe from 1845 to 1848, bringing a revolution to Germany. As word spread across the Atlantic Ocean that Germans could find religious and civil liberties in the United States, a wave of immigrants soon left European shores. Those seeking new opportunities braved the Atlantic in wooden sailing vessels with many entering through the port of Baltimore. From there they headed west, some by stagecoach, horse and wagon, or ox cart, while others sailed down the Great Lakes to the canal system in Ohio. Most of those traveling to central Ohio by canal boat disembarked either at Newark, Lockbourne, or Groveport.

German men settling in Grove City worked as shopkeepers or tradesmen with the largest portion buying farmland around the village. These hardy pioneers grew crops and raised hogs, cattle, sheep, and poultry.

From the late 1840s to the early 1850s, German immigrants gravitated to the central and western parts of Jackson Township—the area that William Breck would plat as the village of Grove City. Included among those German pioneers were W. B. Hemslein, Ludwig Noethlich, Louis Noethlich, Adam Flach, Edward Schirner, Karl Bock, Karl Schoch, Frederick Krebs, Charles Graul, John Kreuzer, Emil Girbert, John Neuhard, Lewis Rost, Jacob Weber, Christ Kientz, George Iftner, Christian Zeigenspeck, Wilhelm Patzer, Frederick Patzer, Mathias Hensel, Christian Meirer, Fred William Galle, Adam Kunz, Ignatz Mueller, Henry Schuler, John Jacob Bausch, John Patzer, Jacob Voeller, K. Richard Graul, John Weber, Henry Quas, John Schilling, Nicholas Kling, Pastor Charles G. Reichert, John Buckholtz, Carl Grossman, and the Riebel families.

Another large group of German settlers purchased land near the Salem Church on the western edge of Jackson Township. Germans of that era tended to have large families, live in a close community, and coalesce around a dominant church. This trend continued as German immigrants moved into the Grove City area.

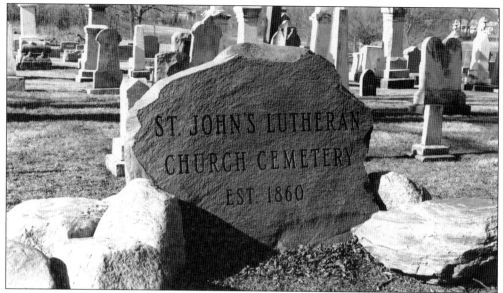

GERMAN LUTHERAN CEMETERY. During the 1840s, German immigrants were making their way to central Ohio and, more specifically, to Grove City. By 1853, Germans had built St. John's Evangelical Lutheran Church, a wooden structure at the northwest corner of Arbutus Avenue and Columbus Street. By 1860, they established the German Lutheran Cemetery, now known as St. John's Cemetery, which adjoins Grove City Cemetery.

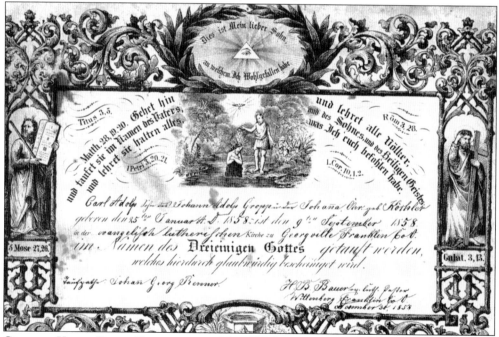

CHARLES KROPP BIRTH CERTIFICATE, 1858. Charles A. Kropp, son of Adolph and Johanna Kropp, was baptized at St. John's Evangelical Lutheran Church in January 1858. Baptismal certificates at St. John's were written in German. Charles had two brothers, William and Louis, and one sister, Wilhelmina. Charles later married Bertha Miller and had two daughters, Clara and Emma.

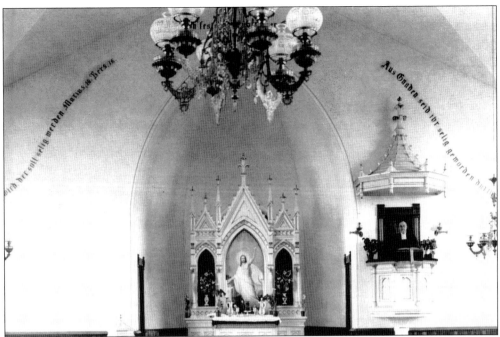

INTERIOR OF ST. JOHN'S. This is how the sanctuary of the "new" St. John's Evangelical Lutheran Church looked when it was built in 1889. Services during these times were held in German. By 1912, regular English services were conducted, but German services were still offered throughout the 1930s. The banner of Bible verses near the ceiling is written in German.

GERMAN SCRIPT. In the years 1853–1920, the minutes of the council meetings for St. John's Evangelical Lutheran Church were handwritten in German script. Each year, the men of the congregation elected a secretary to write the minutes of church council meetings. This document from 1888 is signed by Anton Patzer.

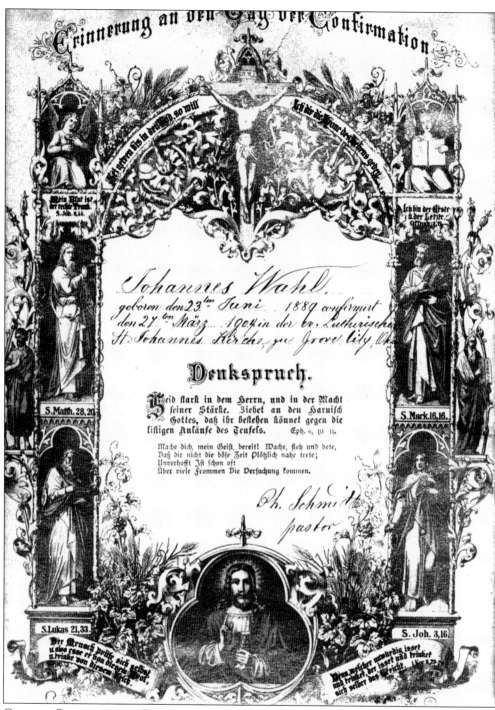

GERMAN CONFIRMATION CERTIFICATE. This is the confirmation certificate of Johannes Wahl from 1889 signed by Rev. Philip Schmidt, then pastor of St. John's Evangelical Lutheran Church. Each confirmand was given a Bible passage, seen in the middle of the certificate, which was done in gold leaf. Confirmation classes were held in German at St. John's until 1912.

OTT-RANKE FARM. Edward Ott was a 16-year-old German immigrant who came to the village to start a new life as a farmer. He later married Pauline Hophe and in 1897 bought a 40-acre farm on Haughn Road. The couple had four daughters with the eldest, Emma, marrying Charles Ranke. The Ott home, later the Ranke farm, still stands near Murfin Fields.

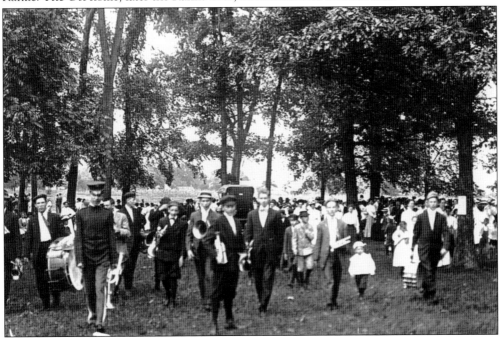

GERMAN BAND. This photograph from 1909 shows the local German band after a performance at the St. John's Evangelical Lutheran Church picnic held in Beulah Park. Band members wore uniforms and performed at church picnics and other area events.

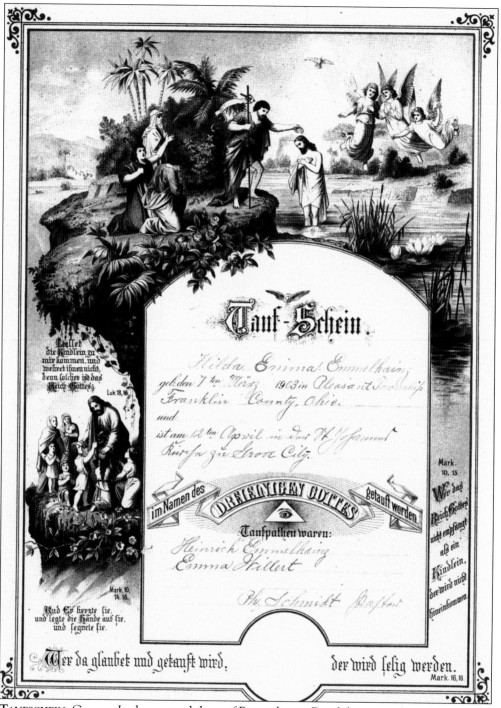

TAUFSCHEIN. German Lutherans and those of Pennsylvania Dutch heritage often had elaborate artwork on their children's baptismal certificates (*taufscheins*). Lutherans and Reformed Germans emphasized infant baptism and brought the taufschein tradition from Europe. Coloring on the document was done by hand. This one was made for Hilda Emma Emmelhainz for her baptism on March 7, 1903, at St. John's Evangelical Lutheran Church.

GERMAN CATECHISM, 1915. This is the St. John's Evangelical Lutheran Church confirmation class of 1915 during a time when most of the children were still taught in German. The pastor at this time, Dr. Emmuel Poppen, had just taken over as the fourth resident pastor of the church. The children's clothing was all handmade.

BIERGARTENS UND DER WHISKY. At one time, not long after the platting of Grove City, there were six saloons within a short distance of one another. When the town was voted dry in 1911, two drinking establishments, the Tabernacle and the Dew Drop Inn, opened outside city limits to serve customers. Later the villagers voted to return the town wet, and it remained that way until Prohibition. This picture shows the beer and whiskey barrels ready to be refilled. Today this is Plank's on Broadway.

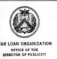

TREASURY DEPARTMENT

WASHINGTON

June 1, 1918.

Rev. Emanuel Poppen,
Evangelical Lutheran St. John's Church,
Grove City, Ohio.

My dear Reverend:

We desire to express to you and the
members of the Evangelical Lutheran St. John's Church
our highest appreciation of the liberal support of the
Third Liberty Loan.

This is an irrefutable proof of patriotism
and loyalty, and a wise act of thrift.

We sincerely hope that "War Savings " will
have a like response.

Very truly yours,

Hans Rieg.

Chief, Foreign Language Division.

HR*W

TREASURY DEPARTMENT LETTER. During World War I, groups with large German populations were looked at with suspicion, thinking their loyalties may lie with the kaiser. The congregation of St. John's Evangelical Lutheran Church sold $50,000 in war bonds, also known as Liberty Loans, to help show its patriotism. The U.S. Treasury Department sent the congregation this letter dated June 1, 1918, stating, "This is an irrefutable proof of patriotism and loyalty."

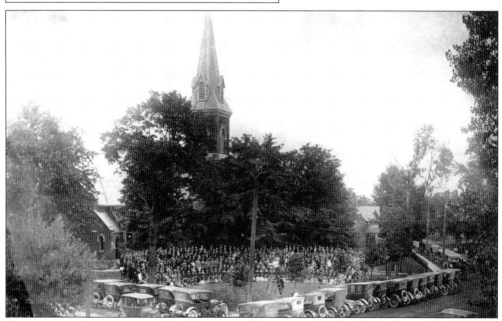

EVANGELICAL LUTHERISCHE ST. JOHANNIS KIRCHE, 1924. In 1924, the congregation of St. John's Evangelical Lutheran Church held its 75th anniversary with a photograph of the entire congregation on the church's front lawn. The congregation that started meeting in 1849 had grown into one of the largest in central Ohio. At this time, services were held in both English and German.

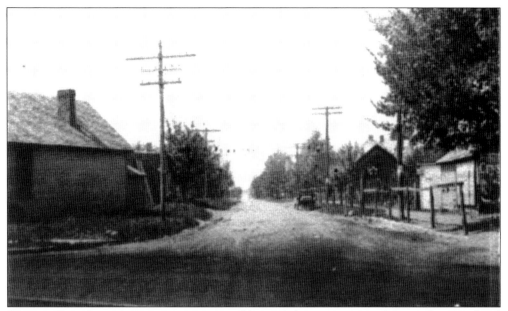

"DUTCH PIKE," 1905. Few structures existed beyond the intersection of Grove City Road and Broadway in 1905. The hitching rack to the right was one of several that lined the streets of Grove City for use by travelers. On Saturday nights, the farm families from the area would congregate here and socialize. The local residents referred to Grove City Road as "Dutch Pike" because most of the residents for several miles west were German (Deutsch) farmers.

LEITHART FARMHOUSE. The two-story brick home built in 1889 on Columbus Street near Leithart Drive is a fine example of German architecture and craftsmanship. On the upper floor is a ladder leading to a trapdoor where family members could step onto the roof. In 1956, Rush and Opal Wade Thomas purchased the building from Hugo and Ellen Leithart and opened Rush and Opal's Party House. Today it is a Coldwell Banker office.

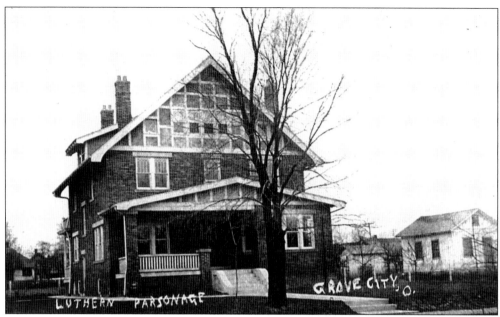

DR. SCHUH'S PARSONAGE. In 1912, Dr. L. H. Schuh arrived in Grove City to become the third resident pastor at St. John's Evangelical Lutheran Church. Dr. Schuh, a former president of Capital University, had five children and needed a proper parsonage for his family. In 1913, the church had this home built on the southwest corner of Columbus Street and Arbutus Avenue, across from the original church. The house still stands.

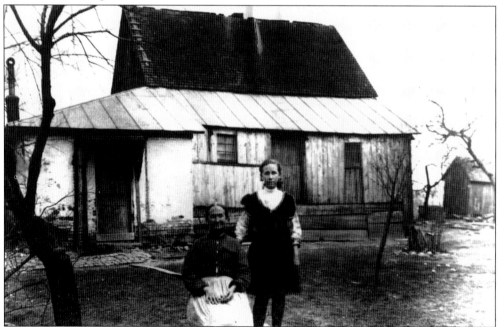

WILLING FARM. Henrietta Weifel Willing left Saalfeld, Germany, in 1848 as a 13-year-old girl and came to Grove City with her sister, Theresa Weifel Grossman, and brother-in-law Carl Grossman. Willing recalled that on the journey to America, she survived mostly on dried fruits and honey. In good weather, the families held dances on the ship's main deck.

Three

FARM LIFE

Of all the hardships that came with settling into wilderness territory in the 1840s, one of the most challenging was farming. The area around Grove City was covered in thick groves of trees, and some of the fertile farmland needed draining. Yet these hearty pioneers prevailed, breaking up the sod and pulling tree stumps with early farm implements pulled by horses.

Most of the early farmers also kept at least one dairy cow for milk, chickens for eggs, and hogs or sheep for meat. Small smokehouses were built to store pork for the winter since there was no refrigeration. Hogs were slaughtered in late fall, and families would often eat fatback, cornmeal mush, and fried potatoes to survive the cold months.

Many farmers in Franklin County in the 1840s had to haul their grain to Franklinton (Columbus) or to Circleville to sell. The first gristmill near Grove City was located on the Weinhart farm about two miles west of the village and a mile north of the present Wal-Mart distribution warehouse. It was operated by Xavias Buckholtz in 1840. Around 1852, William Breck bought this mill and moved it into the village.

By 1849, Ohio produced more corn than any other state and ranked second in wheat. Agriculture would soon feed the economy of Grove City, with many of the young men working on farms to earn their livings. In 1884, the Baltimore and Ohio Railroad increased the shipping of cattle, pork, and grains. About 1885, a grain elevator was built in Pleasant Corners, just south of the Jackson Township line.

Local farmers were kept particularly busy during the world wars due to the fact the United States provided its allies with food. The Grove City Farmer's Exchange was built in 1921, and the village became a hub of the area's agricultural activity.

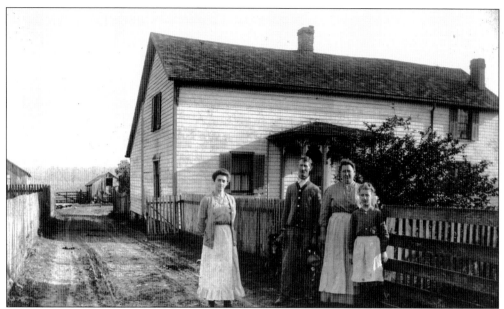

FLACH FARM. William and Emma Flach purchased 87 acres on the north side of Stringtown Road to raise chickens and grow crops. The farm was later split into two halves by the present Thistlewood Drive. This photograph shows the Flachs with daughters Florence, left (who later married Otto Grossman), and Martha, right (who later married Paul White). The house was located where Home Depot now stands.

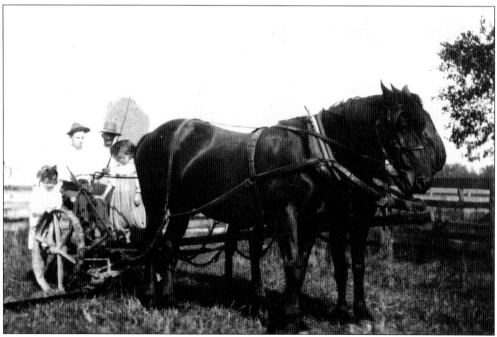

BREAKING THE SOD. William Flach is seen with his daughters getting ready to plow the ground for planting. Most of the area farmers used draft horses to pull equipment. Note the metal wheels on the plow.

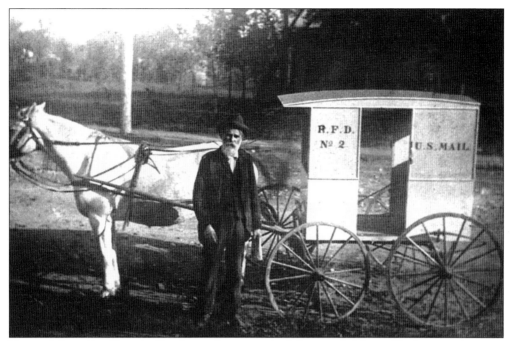

RURAL MAIL. Families who lived away from town had their mail delivered by horse and wagon. Edward Darnell was the postmaster and rural mail carrier from 1897 to 1914. Darnell was also a photographer who preserved Grove City history through the many photographs he took of his hometown.

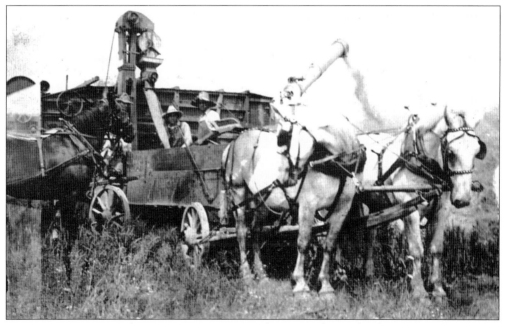

HARVEST TIME. Agriculture was a major source of economy for much of Grove City's existence. Farmers around Grove City used Belgian draft horses because they were strong and muscular yet had a docile nature. Even after tractors became the new way to pull wagons and equipment, some area farmers continued to use horses.

THRESHING. On threshing days, farmers set up six to eight wagons with teams of men to thresh wheat. Heads of wheat were fed into a machine called a separator that parted the straw from the grain. Before threshing day, farmers purchased about a half ton of coal to feed the steam engines on the threshing machines. The coal then heated water to run the machines.

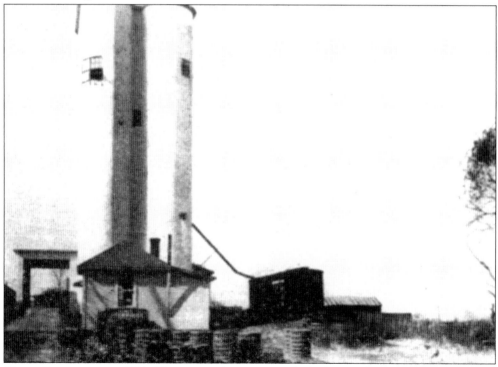

GRAIN ELEVATORS, C. 1921. These grain elevators were built close to the site of William Breck's original gristmill on Broadway. They were constructed shortly after a fire claimed the local Gregg and Shafer Grove City Flour Mill in February 1921. For 86 years, these elevators served as a symbol for Grove City's agricultural prosperity until they were razed in 2007.

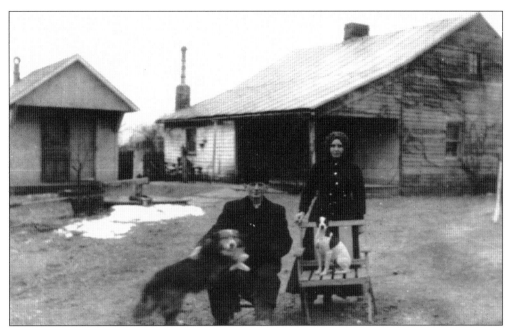

SCHOCH FARM. The home of Edward and Clara Pfeil Schoch was located on the northeast corner of Stringtown and Hoover Roads. Edward, a farmer, was a veteran of World War I. The Schochs specialized in raising ducks and vegetables and had a stand at Central Market in Columbus.

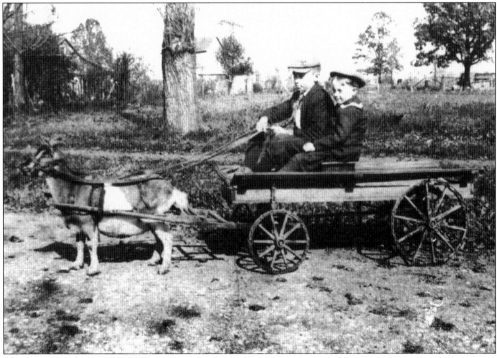

GOAT CART. Elvin (left) and Wayne Mulvaney, along with their grandfather, built this goat cart in 1914. The boys used to run the cart around Grove City as a source of entertainment. Later Elvin used the cart to deliver newspapers.

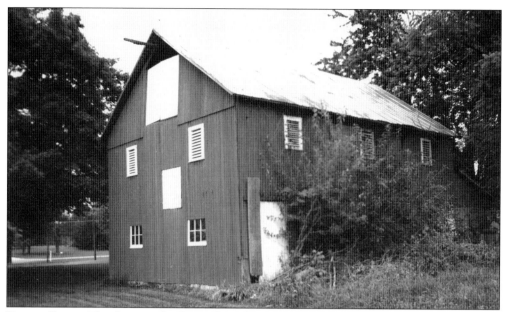

RANKE BARN. This barn at the farm of Frank Ranke Sr. and later Frank Ranke Jr. is a good example of the barns built in Ohio in the late 1800s. At the top of the barn are the doors for the haymow, and right below are windows used to ventilate the barn and help cure the hay. The Ranke farm was located on Hoover Road near Orders Road.

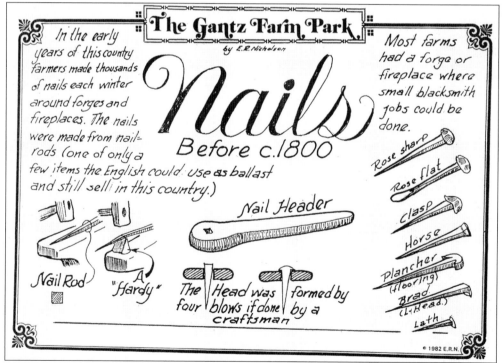

FARM NAILS. Early farmers spent the winter making nails in their fireplaces or forges. The nails were made from nail rods brought over by the English and used as ballast in their ships. The heads of the nails were formed by four blows using a nail header. (Courtesy of Earl Nicholson.)

34

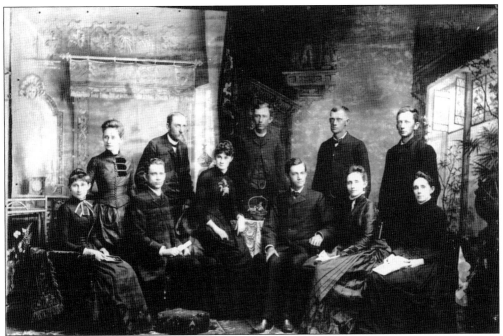

HOOVER FAMILY, C. 1890. This is a picture of the children of George Washington Hoover (born in 1824) and Nancy Jane Smith Hoover (born in 1825). George Washington Hoover, the son of early pioneer John Hoover, had a farm east of Grove City near what is now Gantz Road. Pictured are, from left to right, (first row) Emma, George (born in 1849), Sara, Val, Mary Katherine, and Laura Hoover; (second row) Adah Hoover, Dr. Lewis Smith Hoover, John Hoover, Dr. William Hoover, and Trevitt Hoover.

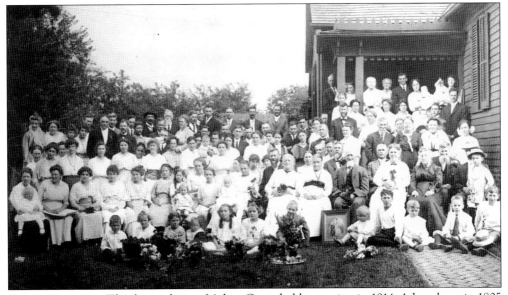

GANTZ REUNION. The descendants of Adam Gantz held a reunion in 1914. Adam, born in 1805 to Andrew and Margrett Harn Gantz in Pennsylvania, moved to a 200-acre parcel on Home Road around 1830. In 1832, he purchased another 100 acres in the area now called Gantz Park. He and his wife, Catherine Pennix, had 14 children.

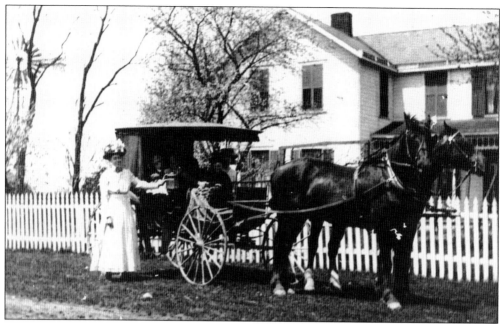

BAUSCH FARM, 1911. This carriage driven by Louis J. Bausch was on its way to St. John's Evangelical Lutheran Church when a photographer stopped it for a picture. The Bausch home was on Beatty Road, which then was called Kegg Road.

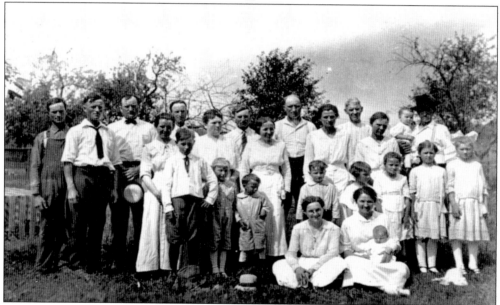

RUOFF FAMILY. The Ruoff family has farmed land in Jackson Township for generations. Family members are, from left to right, (first row) Ida ?, Clare Bettinger Ruoff (Louis Ruoff's wife), and Stanley Ruoff; (second row) Richard Ruoff, Howard Theis, Walter Ruoff, Willard Ruoff, Josephine Ruoff, Lorene Ruoff, Thelma Theis, and Viola Theis; (third row) Flora Ruoff, Mary ?, Clara Ruoff, Clara Ruoff, and Florence Ruoff; (fourth row) Bob Ruoff, George Ruoff, Louis Ruoff, Bill Ruoff, Ben Ehman, Theodore Theis, Clint Galispie, and George Jacob Ruoff holding Virginia Ruoff.

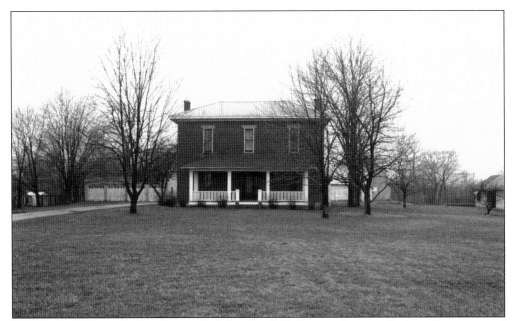

MICHAEL KELLER FARM, 1865. Mikel (Michael) Keller was born in Baden, Germany, and immigrated to California during the gold rush. After spending a few years in the gold mines, Keller traveled to Grove City in 1865 and purchased 135 acres on the south side of Stringtown Road with $7,400 he had sewn into his clothing so it would not get stolen. Keller married Margaret Haenszel and raised hogs, cattle, and grain crops.

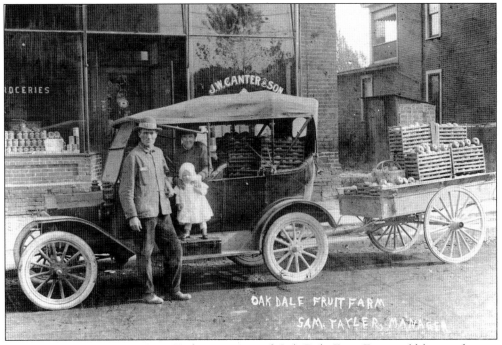

OAK DALE FRUIT FARM. Sam Taylor, manager of Oak Dale Fruit Farm, sold his produce at the corner of Broadway and Park Street. In the photograph are Erle and Hattie Taylor with daughter Kathleen.

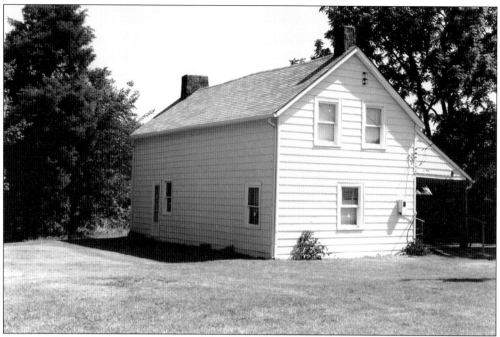

HOOVER/ZINER HOMESTEAD. This house was once a log home and was renovated and modernized in later years. The house stood on the east side of Hoover Road and was torn down to make way for a fire station and the Ziner Farms subdivision.

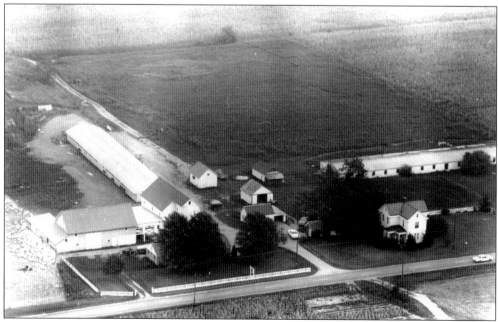

MILLIGAN'S TURKEY FARM. George and Martha Emmelhainz Milligan began their turkey farm business in 1950 and operated it until 1969. In the late 1960s, the Milligans sold land across from the house for the construction of the new Grove City High School. The school opened in the fall of 1970. The land in the mid to upper portion of this photograph is now the Martha's Wood and Briarwood Hills subdivisions.

Four

CHURCHES

The histories of Grove City's early churches all start at one central location—the Highland Mission. The Highland Mission, also called the Union Church, was located near 4086 Broadway. The Highland Mission drew a mixture of European immigrants and those who had come from other states. All three early churches have roots in the Highland Mission.

St. John's Evangelical Lutheran Church began in 1849 with both English- and German-speaking groups. In 1853, the two organized separately yet combined as St. John's Evangelical Lutheran Church. On May 2, 1853, William and Elizabeth Breck donated a lot at the northwest corner of Arbutus Avenue and Columbus Street, and in 1854, the combined group dedicated the "German Evangelical Lutheran St. John's Church." By 1856, the English section withdrew and formed the First Presbyterian Church. In 1889, a massive new church building was dedicated farther east on Columbus Street. It remains the present home of St. John's Evangelical Lutheran Church.

The First Presbyterian Church was formed by 16 members of St. John's who organized in 1856 with village founder William Breck among the first trustees. A wooden church was built on what is now 3496 West Park Street. Later it was moved farther west to 3506–3510 Park Street. A new one-room brick church at the corner of Kingston Avenue and Broadway was dedicated on October 19, 1884. It was razed in 1955. A new church was dedicated in 1958 at 4227 Broadway.

Grove City United Methodist first met at the Highland Mission, but in 1859, the Methodists built their first church at the corner of West Park and Front Streets at a cost of $1,500. The new church, known as Beulah Methodist Episcopal, moved the building to West Park Street during the 1880s. By 1903, the congregation had grown to over 300 members, and the wooden building was moved so a new brick structure could be built on the site. It was dedicated on April 16, 1905. By 1956, a 4.8-acre tract at 2684 Columbus Street was purchased for a new church, which is its present home.

GERMAN BIBLE, 1829. Although Germans emigrating from their home country to America could pack few items for their journey across the ocean, many brought with them die Bibel (the Bible). Religious freedom was one of the reasons they left the fatherland, and the fact many of them brought the good book is a testament to their faith.

BRECK'S DEED TO ST. JOHN'S. In 1853, William and Elizabeth Breck donated the lot at the corner of Arbutus Avenue and Church (Columbus) Street for the construction of St. John's Evangelical Lutheran Church. Breck understood that his new community needed schools and churches to become a vibrant city. In 1856, Breck would help to establish the First Presbyterian Church and would serve as its first treasurer.

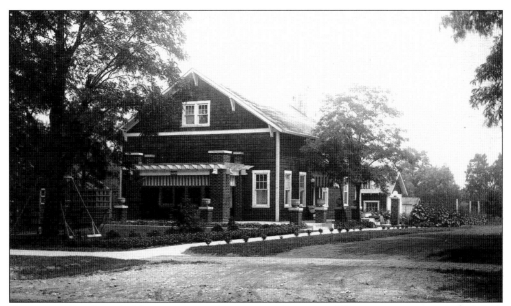

ORIGINAL ST. JOHN'S EVANGELICAL LUTHERAN CHURCH. The congregation of St. John's moved to this location at the northwest corner of Arbutus Avenue and Church (Columbus) Street in 1854. It would serve as the church home until 1889. The original wooden building served in various capacities as a Sunday school, parish house, and parochial and catechetical school until the building was sold in 1921. The building still stands.

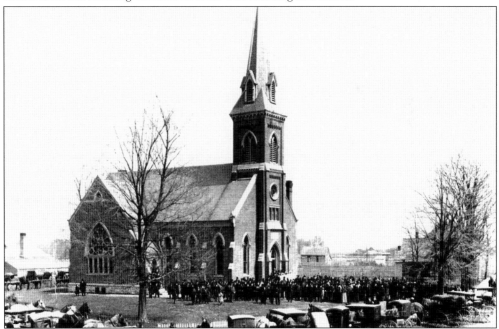

ST. JOHN'S EVANGELICAL LUTHERAN CHURCH, C. 1890. In May 1889, a new brick church was dedicated. The building cost was $11,000, an exceedingly large sum at the time. The log building just to the right of St. John's Evangelical Lutheran Church is St. Paul's Lutheran Church, a Missouri Synod congregation that formed in 1856 and merged with St. John's five years later. The roof of the Grove City Brick and Tile Company is in the left background.

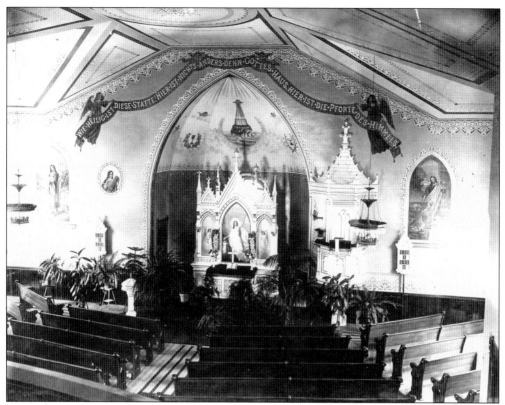

INTERIOR OF ST. JOHN'S. This photograph was taken on Palm Sunday at St. John's Evangelical Lutheran Church, sometime after 1890. The banner near the ceiling says, *"Wie heilig ist diese Statte! Hier ist nichts anders denn Gottes Haus. Hier ist die Pforte des Himmels."* (How holy is this place! Here is nothing other than God's house. Here is the gate of heaven.)

REVEREND REICHERT'S MUSIC. Rev. Charles G. Reichert was the first resident pastor of St. John's Evangelical Lutheran Church. Reichert was born in 1807 in Maumberg, Thuringia, Germany, and received theological training at the University of Halle, Germany. He came to the United States in 1834 and became pastor at St. John's in 1863. Reichert's lyrics were written in German.

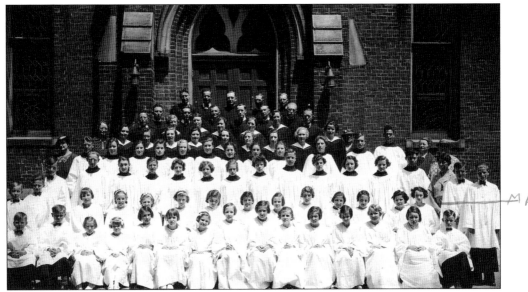

MAG

ST. JOHN'S CHOIRS, 1934. The senior choir, junior Luther League choir, and junior choir joined for this photograph in 1934. The choirs were overseen by Pastor Theodore Proehl, seen at the top middle of the picture. The combined total of choir members that year was 100. Membership at this time was over 900 baptized members, making St. John's one of the largest Lutheran churches in central Ohio.

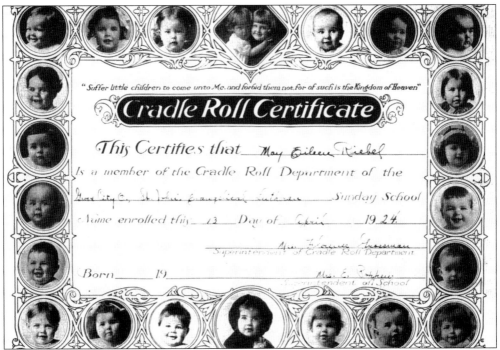

CRADLE ROLL. All three churches in Grove City, the Lutheran, Methodist, and Presbyterian, had cradle rolls for their children. In those days, after the baptism had taken place, the parents received a cradle roll document stating the children were enrolled in Sunday school. This is the cradle roll certificate for May Eileen Riebel, dated 1924.

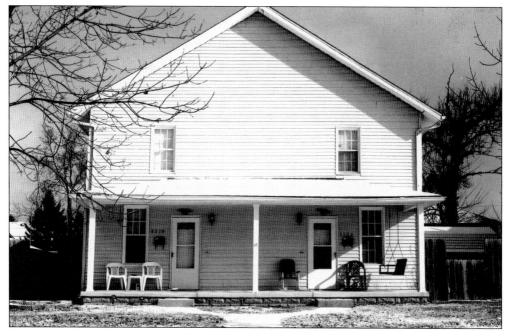

FIRST PRESBYTERIAN CHURCH, 1856. On November 16, 1856, the English-speaking Lutherans presented a petition to the Presbytery of Columbus asking for a Presbyterian church in Grove City. William Breck was appointed treasurer, and the church was built on West Park Street. The building still stands.

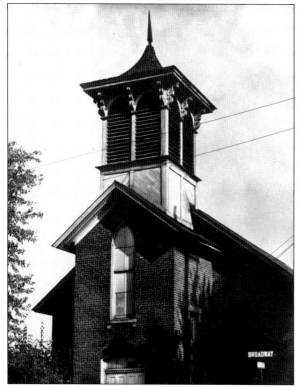

FIRST PRESBYTERIAN CHURCH, BROADWAY, 1883. In 1883, the congregation of the Presbyterian church sold its church building on West Park Street to A. G. Grant for $400 and purchased a lot on Broadway from Grant for $300. That lot became the northeast corner of Kingston Avenue and Broadway. The building had no plumbing and no room for expansion. It was razed in 1955.

OX ROASTS, 1946. By 1950, the congregation of First Presbyterian Church decided to move to a new location farther south on Broadway (west side) on land donated by Dr. Armond B. and Minnie White. The congregation used its annual ox roasts to help raise funds for the building, which was constructed in 1957.

BAPTISM AT FIRST PRESBYTERIAN. This First Presbyterian Church baptismal service shows 12 children being baptized in 1949. The church's pastor was Rev. Ivan L. Wilkins. Included in the picture are Susan Kennedy, Terry McGinnis, Virginia Montoney, Robert Peterson, Barbara Popp, Myrna Rathburn, Trudie Ridderbusch, Beatrice Shirkey, Steven Smith, Mary Kay Temple, Brenda Todd, and John Wilds.

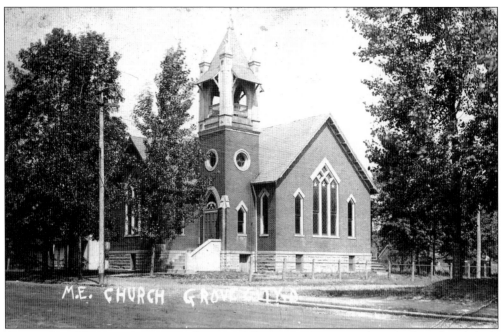

GROVE CITY UNITED METHODIST CHURCH. The Grove City United Methodist Church built its parish in 1859 on West Park Street near Front Street. In the late 1880s, the congregation moved the structure to West Park Street and Lincoln Avenue. A new brick church was built on the old site in 1904. This building is now to a Masonic lodge.

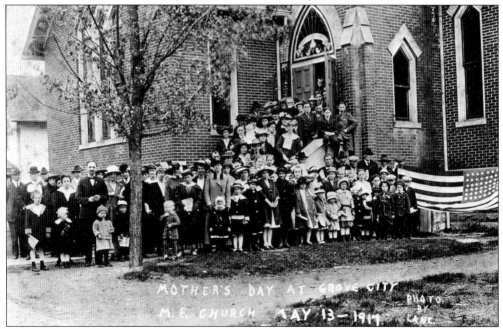

CONGREGATION GROWS. By 1903, the congregation at Grove City United Methodist increased to over 300 members. After the wooden structure was moved and a new brick church was built on land donated by A. G. Grant, the congregation continued to grow. This photograph was taken on the front lawn on Mother's Day 1917—always a big day in the life of the church.

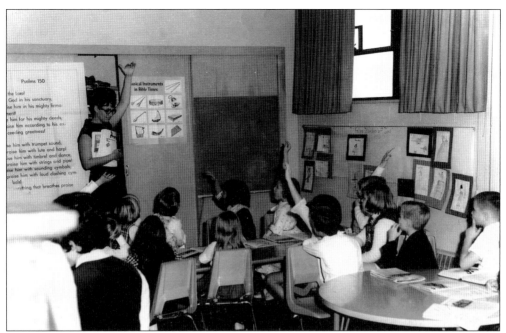

SUNDAY SCHOOL AT GROVE CITY UNITED METHODIST. These children are participating in Sunday morning activities. After World War II and the subsequent baby boom, Sunday school became even more crowded. The church relocated on the north side of Columbus Street just west of Leithart Drive for the present, larger church.

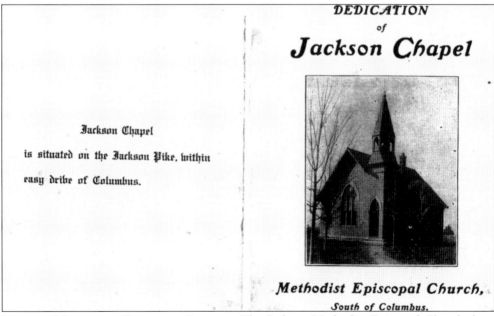

DEDICATION

of

Jackson Chapel

Jackson Chapel

is situated on the Jackson Pike, within

easy dribe of Columbus.

Methodist Episcopal Church,

South of Columbus.

JACKSON METHODIST EPISCOPAL CHURCH. The Jackson Methodist Episcopal Church, later called Jackson Chapel, was founded in the 1850s and has stood on the corner of White Road and Jackson Pike since 1859 on land donated by William Breckenridge. Previously the congregation met in Breckenridge's home and in the Hopewell School near the corner of Stringtown Road and Jackson Pike.

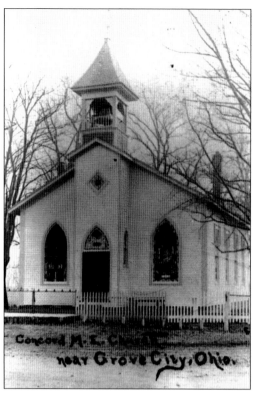

CONCORD METHODIST EPISCOPAL CHURCH. The Concord Chapel was founded in 1847 and met in an old log meetinghouse. In 1859, the Concord Methodist Episcopal Church was erected at the corner of State Route 665 and Hoover Road. The Old Concord Cemetery, maintained by the Jackson Township board of trustees, lies directly east of the building. A second cemetery, the Concord Cemetery, is directly south of the building. This building is now a veterinary clinic.

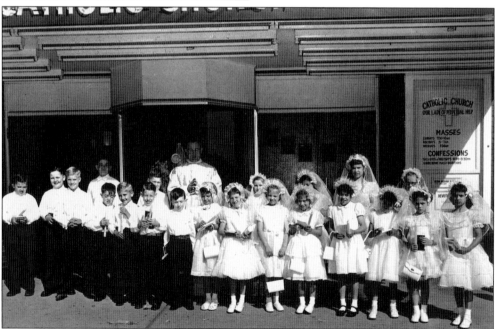

OUR LADY OF PERPETUAL HELP CHURCH, C. 1954. The Catholic diocese leased the former Kingdom Theater, now the Little Theatre Off Broadway, in 1954. For a brief time the two enterprises overlapped. Pictured here are the children celebrating their First Holy Communion with Fr. Richard Hock, the parish's first priest.

Five

TRANSPORTATION

Grove City's first settler, Hugh Grant Sr., traveled to the area on a single ox cart through barely cleared trails. Throughout the 19th century, horseback and stagecoaches were the primary means of transportation. Mud often made the early roads impassable, and the preferred season of travel was wintertime when the ground was frozen. The first major route through Grove City was the Columbus and Harrisburg Turnpike. In its early years, this turnpike was little more than a trail of felled trees and cleared brush, with an occasional stump poking through. In 1848, the turnpike was graded and graveled. Due to the heavy traffic, however, it had to be surfaced with logs or planks, to become a corduroy road.

The Columbus and Harrisburg Turnpike was used not only by farmers and merchants but also by visitors who ended up permanently staying in the village. In all likelihood, it was the Columbus and Harrisburg Turnpike's development that inspired William Breck to develop the small settlement that was situated halfway between Harrisburg and Columbus. In 1852, both the Franklin and the Cottage Mill Turnpikes were built, connecting people throughout the rest of Jackson Township. Other early roads included Stringtown, Brown, Hoover, Alkire, Demorest, Grove City, and Concord.

While the Baltimore and Ohio Railroad began offering passenger service in 1891, it was the interurban electric hourly commuter service organized by A. G. Grant in 1898 that brought excitement and new residents to Grove City. The Grove City and Greenlawn Street Railway, as the interurban was first known, offered half-hourly service and significantly spurred development of the village. By 1916, the state had taken control of the Columbus and Harrisburg Turnpike because it was part of the major artery connecting Cincinnati, Columbus, and Cleveland. By 1928, bus service and the horseless carriage would cause the demise of the interurbans, as Grove City, like the rest of America, became enamored with the automobile. The 1950s and 1960s ushered in the modern highway era with the development of Interstates 70 and 71 and the connecting outer-belt Interstate 270. Grove City is now one of the most connected cities in America.

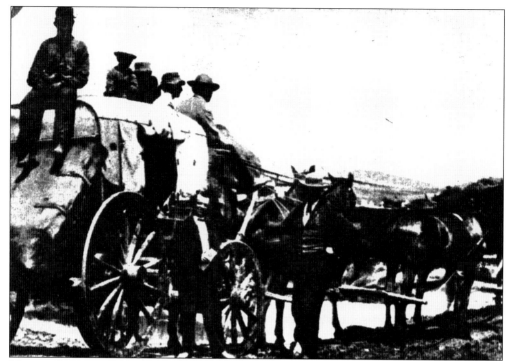

MOUNT STERLING HACK, C. 1884. Prior to 1884, the primary manner of group transportation was the stagecoach. In the Grove City area, the coaches traveled the three major turnpikes and stopped at various stages along the way. The stagecoach line was also the major means of communication between Mount Sterling, Grove City, and Columbus until the interurban and the telephone lines were established.

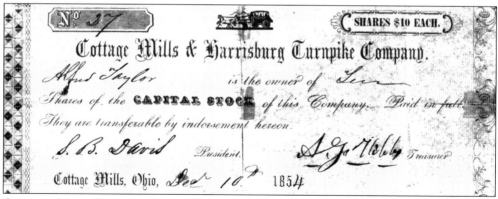

COTTAGE MILLS TURNPIKE STOCK CERTIFICATE. In 1851, Adin Hibbs, Levi Strader, Solomon Borror, Isaac Miller, William Duff, and associates incorporated the Cottage Mills and Harrisburg Turnpike Company. Constructed in 1852, around the time the other two township turnpikes, the Columbus and Harrisburg Turnpike and the Jackson Turnpike, were being built, the Cottage Mills Turnpike was seven and a half miles long with one tollgate.

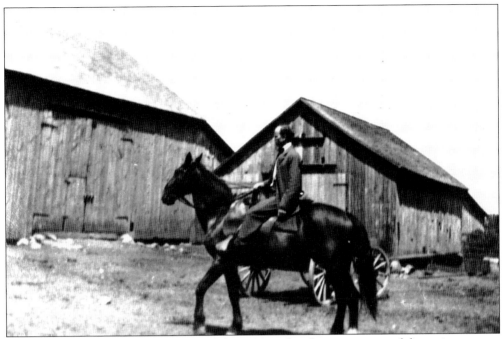

WILLIAM FLACH ON HORSEBACK. Until the 1890s, riding horses was one of the easiest ways to travel. Even after the introduction of more modern forms of transportation, it was often faster to travel by horseback between locations not served by rails or paved roads. This picture was taken at the Flach farm, east of Stringtown Road, which is where the Home Depot is now located.

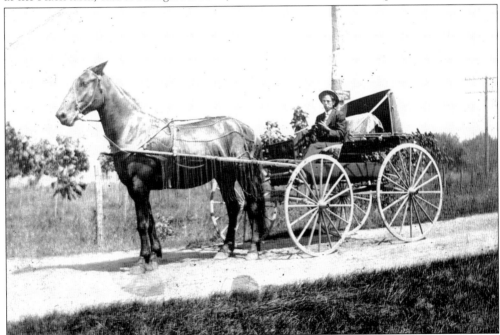

FARMER RANKE IN BUGGY, C. 1900. The Rankes owned a dairy farm on White Road, which is now part of the Berryhill Addition. Henry Ranke is seated on the runabout carriage. Note the fly net protecting the horse and the advertising posters on the telephone poles in the background.

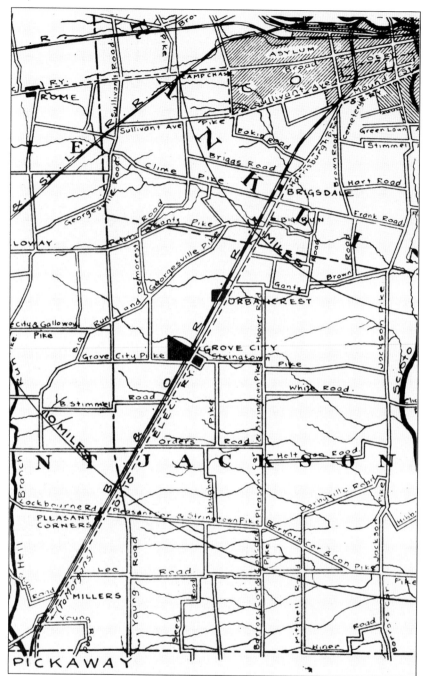

MAP OF INTERURBAN. Interurbans were rail transportation systems that connected towns. In 1889, the first electric-powered interurban in the United States ran in central Ohio. Three years later, A. G. Grant and Joseph Briggs of Briggsdale decided to develop one for Grove City, but their original attempt had unscrupulous investors, so they started their own. This map shows the Baltimore and Ohio Railroad line on the west side of the interurban line, which ran north to Columbus and south to Orient in Pickaway County. The map also shows some of the more important roadways of the time.

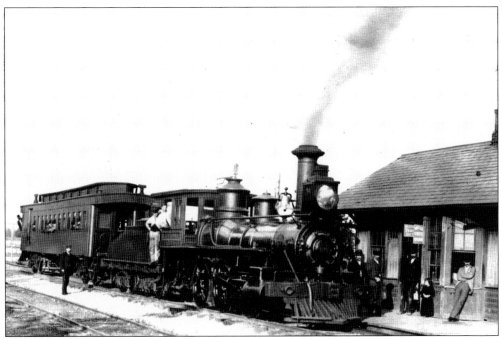

STEAM TRAIN, 1892. In 1882, Grove City learned that the Cincinnati, Midland City, and Columbus Railroad (later the Baltimore and Ohio) planned to build a line through town. By March 1884, the construction gang reached the village and proceeded on to Columbus. The railroad reportedly gave free rides to anyone who shipped goods. By 1890, a daily commuter train left the village every morning and returned home in the evening.

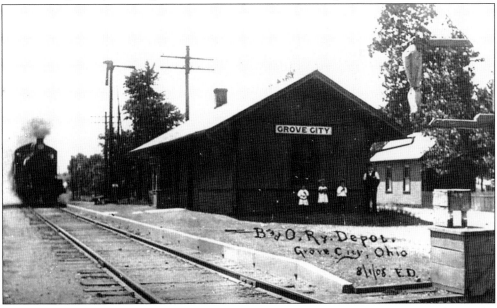

GROVE CITY DEPOT, 1908. In 1884, the train passed through Grove City, stimulating the shipping of cattle, pork, grains, and lumber. The depot also served as the Western Union office. In 1972, the Grove City Jaycees started a Save the Depot project. The project was successful, and after a major refurbishing, a dedication was held in 1975. The depot still stands today.

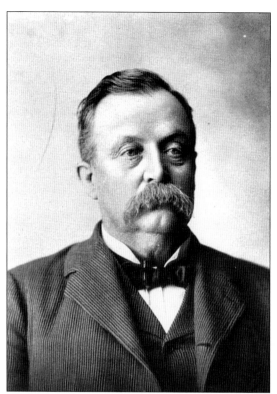

A. G. GRANT (1840–1913). It would not be an overstatement to call A. G. (Adam) Grant Grove City's most successful entrepreneur. Grant built a general store, a subdivision (which more than doubled the village's size), the town's sewers, an interurban line, and the first village park. He owned and operated an ashery, a brick and tile factory, and a bank. He donated property for schools and churches. Other than William Breck, no other individual left such an important imprint on the city as Grant. (Courtesy of *Centennial Biographical History of Columbus and Franklin County*.)

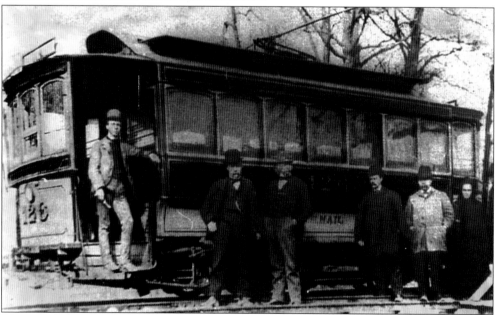

INTERURBAN TRAIN, C. 1901. Grant bought several used passenger cars for the Grove City and Greenlawn Street Railway (as it was first known). These cars had originally been used as horse-drawn passenger cars before they were converted to electric cars. The interurban gave local farmers the first reliable means to quickly transport milk and other perishable items to a larger market. Grant is the second man on the left with the bowler hat.

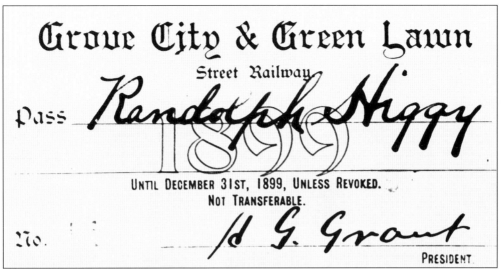

Grove City & Green Lawn

Street Railway

Pass *Randolph Higgy*

1899

UNTIL DECEMBER 31ST, 1899, UNLESS REVOKED.
NOT TRANSFERABLE.

No.

A G. Grant

PRESIDENT.

HIGGY-GRANT PASS, C. 1898. The round-trip to Columbus cost 15¢ and ran half-hourly or hourly, from 5:15 a.m. to 11:44 p.m. The interurban ran through Grove City from 1898 to 1927 and changed hands and names several times. It was intended to reach as far south as Washington Court House but only made it as far as Orient.

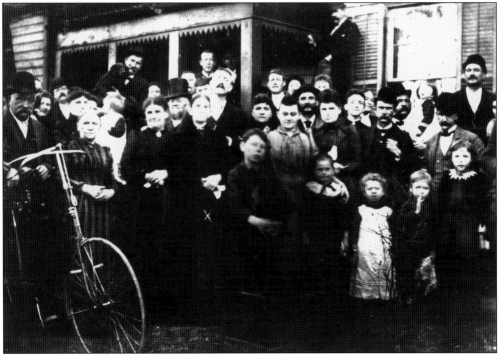

FIRST BICYCLE IN GROVE CITY, 1891. The bicycling craze took over America in the 1880s. Many people expected the bicycle to replace the horse. Cycling became a popular leisure activity and increased the demand for improved roads. Pictured here is the first reported bicycle in Grove City. On the left is Grant with his signature bowler hat.

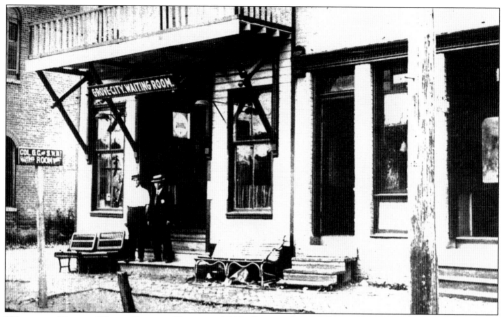

WAITING ROOM, KEGG STORE, BEFORE 1912. Interurban tickets were sold at the Kegg Store, which offered a waiting room for passengers. In 1912, this store and the buildings on both sides were destroyed by fire. It was also the site of the first licensed whiskey exchange.

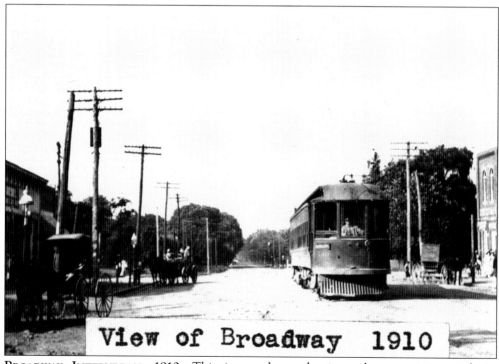

BROADWAY INTERURBAN, 1910. This image shows the interurban coexisting with its predecessor, the horse and buggy. At the time, the west side of Broadway north of Park Street had limited development.

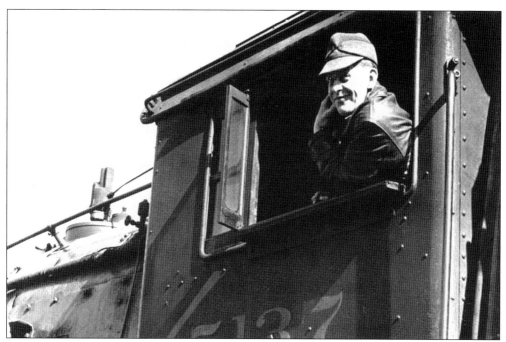

ENGINEER, C. 1940s. Pictured is George DeVault, engineer for the Baltimore and Ohio Railroad on engine No. 5137. The trains in the early 1940s were busy transporting troops and goods for the war effort. Passenger trains passed through Grove City until 1956. By 1972, the railroad was forced to shut down its freight agent and car-loading service.

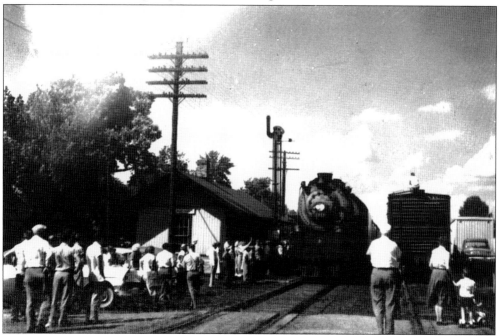

LAST PASSENGER TRAIN IN GROVE CITY, 1956. Residents turned out to say farewell to the last commuter train passing through Grove City. While it was a sad day for rail fans, commuters would soon have access to the interstate that was being built at the edge of town.

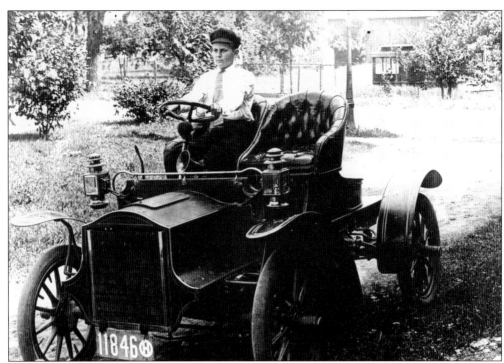

PACKARD, 1910. In the early years of the automobile, horse enthusiasts were reluctant to share the road. Sometimes an automobile would backfire, causing a horse to bolt, often with serious consequences. A surprising number of accidents were also caused by pedestrians stepping in front of automobiles. However, interest grew, and motoring became a favorite leisure activity.

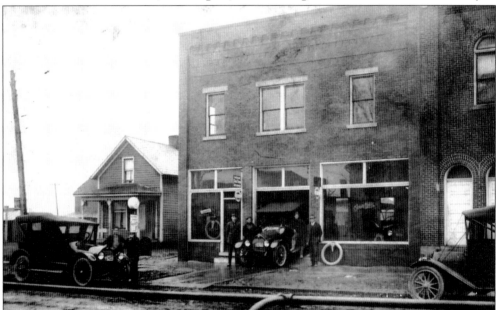

JOHNSON'S GARAGE. This building on East Park Street served as the new location of Johnson's Garage after moving from the old location on Broadway. Carl Johnson sold automobiles and did mechanical repairs.

VIEW OF HOOVER ROAD, C. 1905.
This is a view of Hoover Road looking south from Gantz (now Home) Road. The road is named after Revolutionary War veteran John Hoover, who had to buy his 200-acre farm twice because he was swindled the first time. He and his wife, Margaret, raised their nine children here. The Hoovers were farmers, doctors, pharmacists, and teachers. Hoover died on his farm in 1840.

U.S. ROUTE 62 AND STATE ROUTE 3, 1933. This photograph shows the rural nature of Routes 62 and 3 as it leaves the village. In 1916, the state took control of the road because of its importance as the only artery connecting Ohio's three largest cities, Cincinnati, Columbus, and Cleveland (the "3C Highway"). Ohio was known to have some of the best and most numerous paved roads in the country.

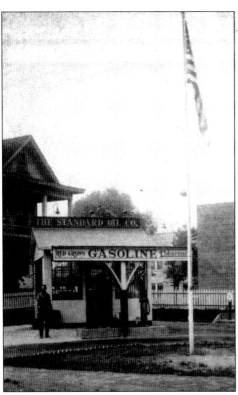

STANDARD OIL STATION, BEFORE 1921. The Standard Oil gas station is located on the northwest corner of Park Street and Broadway. In the background, the Woodland Hotel is still standing.

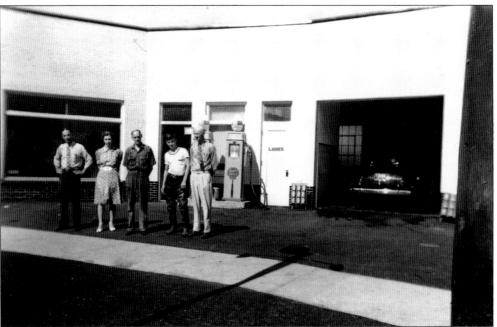

LEACH BUILDING, 1940. The Leach Building was home to Massie Motors, a Chevrolet dealership where Home Country Moods and the Grove City Jewelers now operate. Pictured are, from left to right, Herb Massie, owner; Madge Grooms, bookkeeper; unidentified; Paul Pupp, mechanic; and Charles Meadows, mechanic.

Six

SCHOOLS

Although subscription schools began to appear as early as 1815 on the outskirts of newly formed Jackson Township, Grove City did not build a "public" school until 1853—right after founder William Breck laid out the plat for the village. Breck donated land on the north side of School Street (Park Street) on the western side of a lot that lay between what is now Arbutus Avenue and Third Street. Since the village had not yet incorporated, the deed was made out to the Jackson Township Board of Education. The one-room log structure built at this site soon filled with students as pioneer families made their way to Grove City. In 1866, a larger school was needed, and citizens organized a special school district so local residents could be taxed by the county auditor.

In June 1869, Elizabeth Breck, widow of William, sold the lot adjoining the school grounds to the east of the log structure. Dr. Joseph Bullen, M. A. White, and Reuben Haughn were named directors of the Grove City School District.

A two-room school was constructed in 1869, but, again, the school filled, and by 1888, a four-room school was planned. The west lot was purchased from Jackson Township, and the two-room school was moved to another site. The new school was built from bricks made at the Grove City Brick Yard owned by A. G. Grant. Two other additions were made in later years. This structure is known in local history as the Park Street School. High school classes opened in a portion of the upper floor of the building, and the first class of graduating students (four girls) held commencement in 1896. There were 142 students in all that year.

In 1910, a new Grove City High School was built farther east on the south side of Park Street. In 1920, the Grove City Board of Education dissolved, and the Jackson Township Board of Education took over the entire Grove City school system. The high school was known officially as the Jackson Township Rural High School. In 1928, a new Jackson Township-Grove City High School opened its doors directly east of the old high school. The old high school building became a junior high. In 1950, a second primary school opened in Grove City—the Kingston Avenue School.

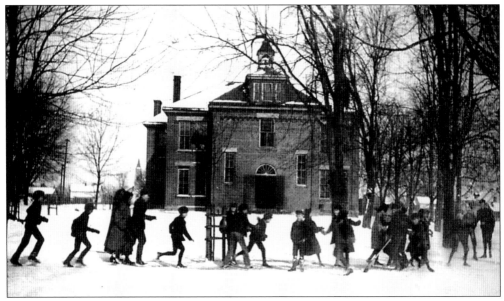

RECESS AT PARK STREET SCHOOL, 1910. By 1853, Grove City had its first school inside the village boundaries on property donated by William Breck. It was a wooden one-room school constructed of logs and slab board. In 1870, a two-room wooden school was built for a population of 143 residents. By 1888, the village had grown so large that voters passed a bond issue to build a four-room brick grammar school, known as the Park Street School. It was razed in the 1960s.

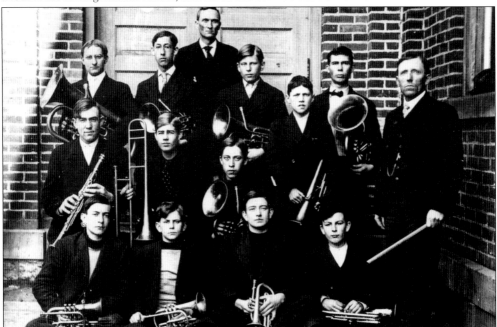

GROVE CITY HIGH SCHOOL BAND, 1906. Members of the Grove City High School Band are, from left to right, (first row) Earl White, Walter Darnell, Ralph Miller, and Pearl Gunderman; (second row) John Seeds, Pearl Nichols, Grover Davis, Orlando Corzilius, and ? Dumas (director); (third row) John Linebaugh, Frank Weygandt, Arthur Spillman, and Floyd Delashmutt; (fourth row) A. C. Freis, school superintendent.

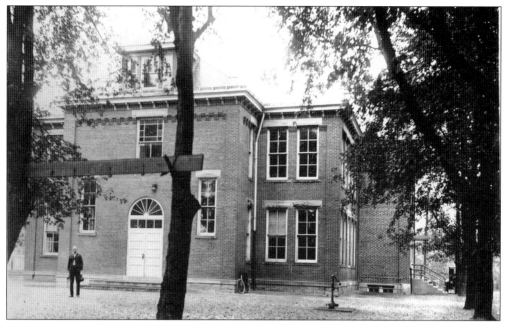

PARK STREET SCHOOL, C. 1920. This photograph shows the main door of the Park Street School. The upper part of the school is the floor where the original high school classes took place from 1894 until 1911, when the Grove City High School opened. The first high school students graduated in 1896: Evelyn McGiven, Lillie Barbee, Lizzie Jones, and Sally Jones. At this time, the school had two outhouses.

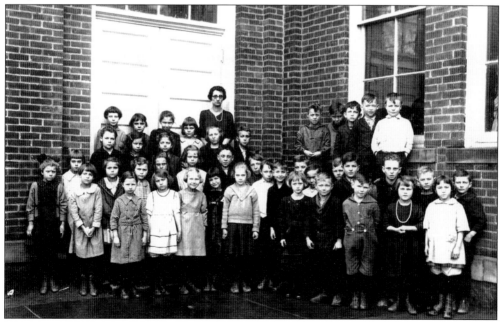

MINNIE SCHILLING'S CLASS, 1922. The year this photograph of the first-grade class at Park Street School was taken, a third section was added on the northeast corner. Water and inside modern toilets were installed for the first time, and all six potbellied stoves were removed for central steam heating. The building was also wired for electricity for the first time.

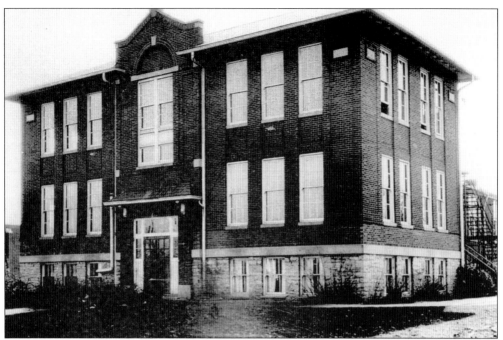

GROVE CITY HIGH SCHOOL (1910–1928). The original Grove City High School opened in November 1910 on East Park Street. The school opened with 81 students, 42 of whom came from other township schools. In July 1920, the Jackson Township Board of Education merged with Grove City Village Schools to form the Grove City-Jackson Exempted Village District. In 1928, a new three-story high school opened directly east of the old high school. The old building became known as the Jackson Building.

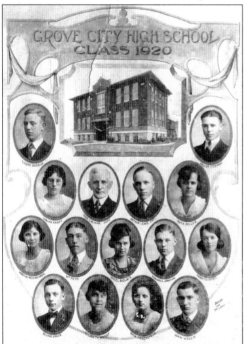

CLASS OF 1920. Graduating classes throughout the 1920s averaged about 20 members per year. Members of the Grove City High School class of 1920 are, from left to right, (top row) Eugene Borror and Walter Eyerman; (second row) Thelma Knight, Prof. C. M. Lehr (superintendent), Arthur Lewis (president), and Ruth Miller; (third row) Martha Neiswender, William Feyh, Hazel Bidlack, Marshall Johnson, and Frances Seeds; (bottom row) Reland Sager, Elizabeth Wright, Ruth Ziegenspeck, and John Welch.

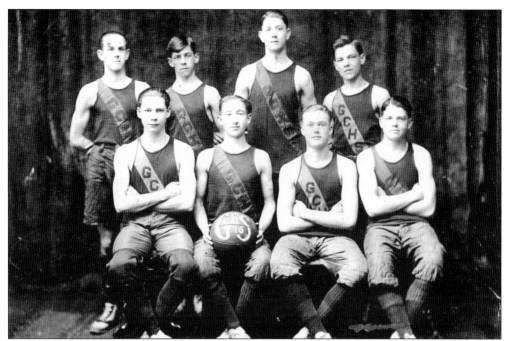

GROVE CITY HIGH SCHOOL BASKETBALL TEAM, 1916. Grove City first played basketball as a team in the basement of the high school as an indoor winter activity. Members of the team are, from left to right, (first row) Eldon Sager, Elvin Weygandt, Cletus Ralston, and ? Smith; (second row) Harold Windsor, ? Mitter, Boyd Kegg, and Abbie Corzilius.

GIRLS' GYM UNIFORM. Marie Deyo Graul shows off the gym uniform worn in the early days of physical education in high school. The Grove City High School girls' gym classes had some form of uniforms with bloomers until the late 1960s.

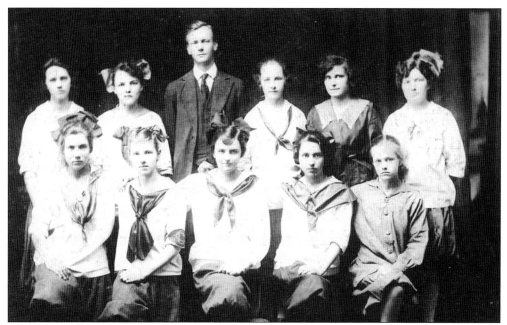

GIRLS' BASKETBALL TEAM, 1919. Basketball became popular with both boys and girls after it was introduced to the high school in 1911. Members of this early team are, from left to right, (first row) Altha Melton, Aleta Shover, Frances Breckenridge, Esther Mayer, and Frances Seeds; (second row) Margaret Goss, Wilma Corzilius, Professor Horton, Lillian Leach, ? Phalor (coach), and Martha Hoddy.

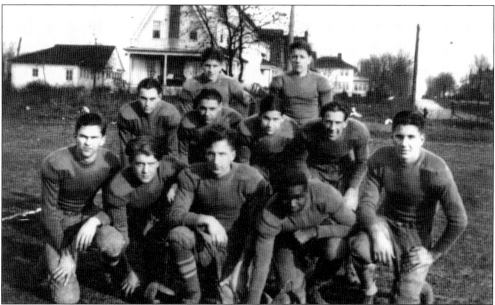

FIRST FOOTBALL TEAM, 1929. This is the first football team fielded by Grove City High School in the fall of 1929. Its record was 5-3. Members of the team are, from left to right, (first row) Cletis Johnson, Eugene Brink, Don Endres, Clarence Ramsey, and Orville Koehler; (second row) Ralph Grossman, George Ollam, Carl Kunz, and Lloyd Shady; (third row) Oscar Jahn and Richard Brodt.

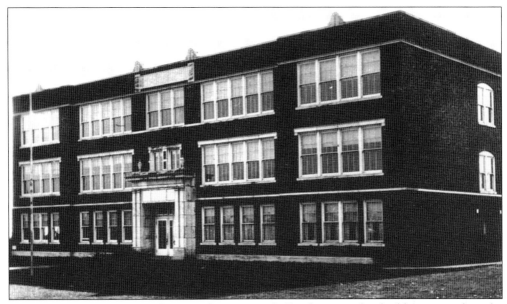

JACKSON TOWNSHIP HIGH SCHOOL (1928–1970). By the time this building opened in the fall of 1928, the Grove City School District had merged with the Jackson Township School District. The new high school opened with a large gymnasium built with an adjoining stage. In the mid-1950s, the school added an even larger gymnasium and more classrooms. In 1970, the building was converted into a middle school. In 2001, the building was torn down.

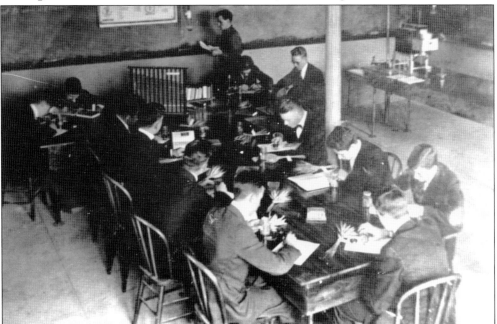

VOCATIONAL AGRICULTURE. One of the largest classes at Grove City High School in the 1920s and 1930s was the vocational agriculture class. Farm boys would take class work in various agricultural subjects plus selected home projects. Projects included construction and repair of farm buildings, concrete work, machinery and gas engine repair, and overhauling. A Young Men's Farming Club was formed in 1924 to promote farm life.

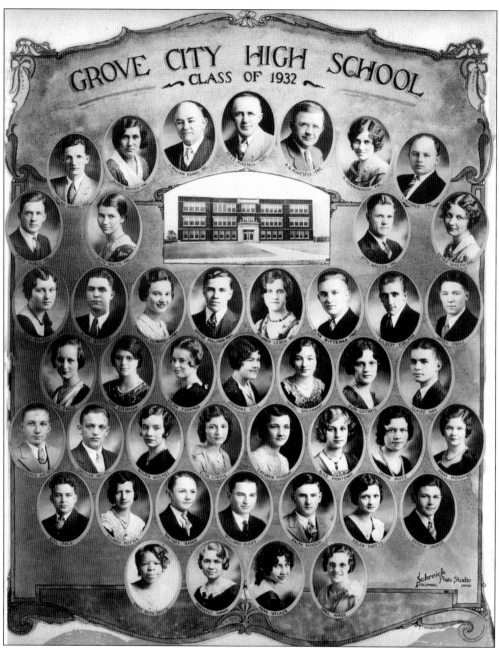

CLASS OF 1932. In the 1930s, the number of high school graduates averaged about 47 per year. The class members in this photograph are, from left to right, (first row, bottom) Annie Ruth Smith, Margaret Swank, Mona Welker, and Opal Wade; (second row) Nial Pace, Mildred Potter, Whitney Rader, Williard Ruoff, Ralph Schoch, Helen Sheets, and Harold Shover; (third row) Lawrence Haegele, Chester Helsel, Wilma Holmes, Elsa Lindig, Cathryn Murray, Alice Montoney, Louise Motz, and Mary Meadows; (fourth row) Louise Engle, Mary Eyerman, Velma Fuhrman, Josephine Gill, Isabel Goldhardt, Alma Gutheil, and Claire Hay; (fifth row) Ruth Bausch, Alvin Borror, Margaret Albright, George Milligan, Mildred Lerch, Alan Witteman, Gilbert Edelman, and James Engle.

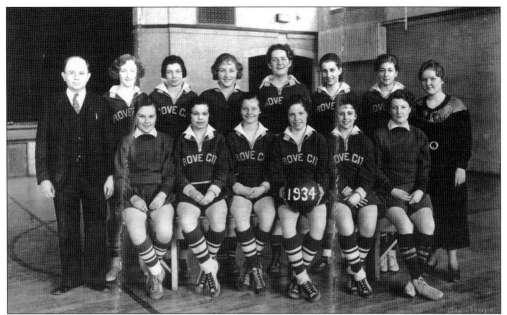

GIRLS' COUNTY BASKETBALL CHAMPIONS, 1934. This team brought home the 1934–1935 Franklin County girls' championship trophy. Members of the team are, from left to right, (first row) Jean Hoover, Gladys Ollam, Mildred Meadows, Edna Durr, Jean Seipel, and Edith Thomas; (second row) Loy Mosher (coach), Lenore Thomas, Dorothy White, Carol Frank, Marjorie Linebaugh, Kathryn Keller, Phyllis White, and Marjorie Mikesell (coach).

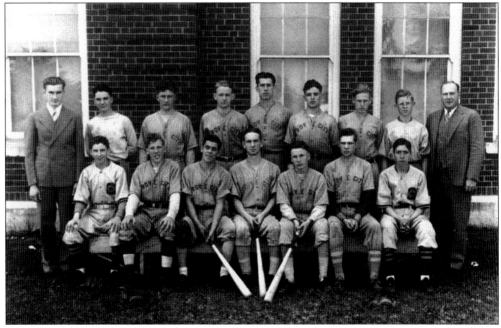

BASEBALL TEAM, 1937. This is the Grove City baseball team in 1937. Pictured are, from left to right, (first row) Donavon Wade, Ned Breckenridge, Pete Kunz, Leonard Mueller, Bill Black, Geo Seum, and Wayne Davis; (second row) Kenny Strickler (manager), Earl Koehler, Marvin Shover, Don Grant, Bill Watkins, Paul Sheller, Ted Ray, Bob Trapp, and Glenn Francis (coach).

CHEERLEADING LETTER, 1943–1945. Cheerleaders from the era 1943–1945 cheered for both the football and basketball teams. In those days, Grove City High School played in the County League. During that period, the 1943 football team won the Franklin County championship, the 1943 basketball team won the Franklin County championship, and the 1944 basketball team qualified for and won the district tournament.

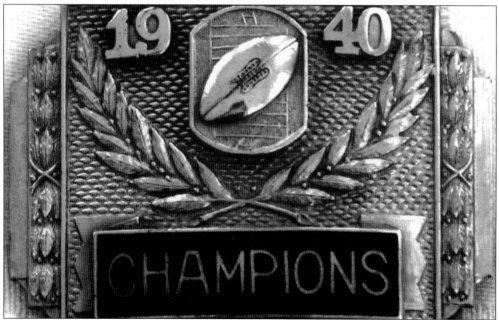

COUNTY FOOTBALL CHAMPIONS, 1940. Members of the Grove City High School football team were crowned Franklin County champions in 1940 and received these belt buckles for their victory. The team was coached by Ellsworth "Red" Trego and had a 5-1 league record. Harold Jones was the captain.

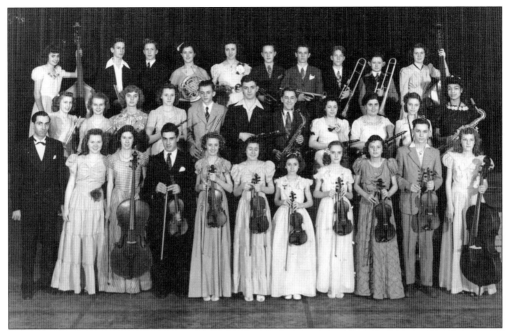

ORCHESTRA, 1946. Members of the orchestra are, from left to right, (first row) Richard Harris (director), Joan Kunz, Dorothy Davis, Merritt Lindig, ? Scott, Lillie Barbee, unidentified, ? Scott, Rosemary Keil, Jerry Eyerman, and Nancy Gall; (second row) Marianne Barbee, Virginia Weishaupt, Nyla Stratton, Phyllis Lewis, Bob Mosher, Roy Grossman, Don McVey, Norma Jean Hughes, Dorothy Hensel, Virginia Kraus, and unidentified; (third row) Lois Bender, two unidentified, Ann Craig, Joan Thomas, three unidentified, Larry Smith, and Joan Emmelhainz.

The Gypsy Rover
A Romantic Musical Comedy

Presented by
The Music Department
of Grove City High School

CLASS PLAY. On March 8, 1935, the Grove City High School music department presented *The Gypsy Rover*, a romantic musical comedy. Both the high school orchestra and chorus participated in the theatrical production.

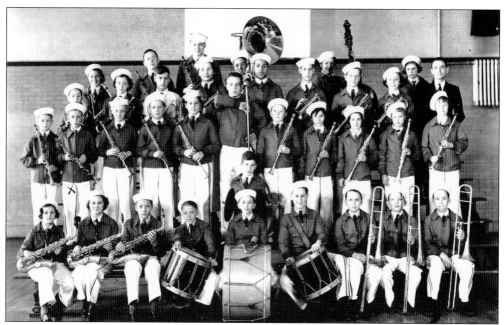

BAND AND CHORUS. The Grove City High School Band (seen in the image above) has a tradition of excellence. Among the members of the 1937 band pictured are Frances Hoffman, ? Foreman, Doris Jane Rumfield, ? Borror, Don Breckenridge, Jack Graul, Kenneth Thomas, Gene Gunderman, Don Turner, ? Bond, Bill Phillips, Margene Breckenridge, Jed Koehler, June Weishaupt, Don Washburn, Majorie Grossman, Margene Mikesell, Aldean Wallace, Lynn Wickliff, Martha Breckenridge, Donna Arick, Bob Sommer, Charles Foreman, Lucille Patzer, Fred Russell, Lynn Fisher, Viola Patzer, Edwin Smith, Marilyn Breckenridge, Thelma Huffman, and Fred Mayer (director). Seen in the image below, members of the girls' chorus in 1949 performed at Grove City High School throughout the year at various events. The photograph shows the chorus on the high school stage. Student Marlyn White is seen at the piano. Richard Harris is the director.

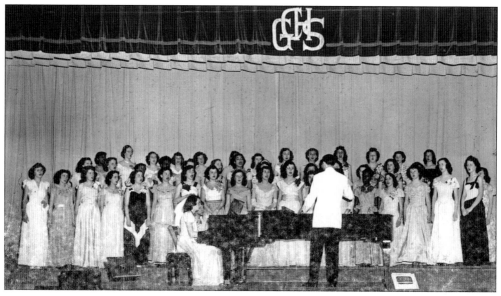

Seven

COMMUNITY LIFE

As houses and businesses grew from empty lots and wooded acreage, a vibrant community life took hold in the village of Grove City. In the early years, Grant's Auditorium on West Park Street held dances, concerts, and shows. The Kingdom Theater on Broadway opened in 1915 and featured silent movies accompanied by a live piano player. When the new Jackson Township High School opened in 1928, its large stage featured student plays, concerts, and operettas to entertain the community.

In 1917, the Women's Community and Women's Civic Clubs met separately but combined to build and maintain a shared building on Civic Place for their meetings. The building was also rented out for wedding and other receptions.

Grove City's early library began in 1891, when local residents combined their personal libraries in Harsh's Drug Store. In 1923, the Women's Civic Club moved the library to a small building at Broadway and Civic Place.

Grove City had many fraternal societies for the gathering of like-minded individuals. The Order of Good Templars organized in 1855, Odd Fellows organized in 1876, Knights of the Pythias in 1892, and the Masonic and Eastern Star lodges in 1923.

During World War II, high school students could frequent the Teen Canteen held on the second floor of the post office building on the southeast corner of Broadway and Park Street. Families often hosted soldiers from Lockbourne Air Force Base to give them a "taste of home" during the war years.

In 1952, Grove City celebrated its centennial with a weeklong celebration. At that time, the population was 2,500 residents. In 1953, Grove City's first park, Windsor Park, ushered in community youth baseball. It is still going strong.

GROVE CITY JAIL, 1893. The town's first jail was a crude wooden structure built in 1866 with an iron lock on the door and iron rods over the windows. Its first occupant was a Mrs. Ike, who was arrested for disturbing the peace. In 1893, a brick jail was constructed. This more modern building had six individual cells reinforced with heavy metal.

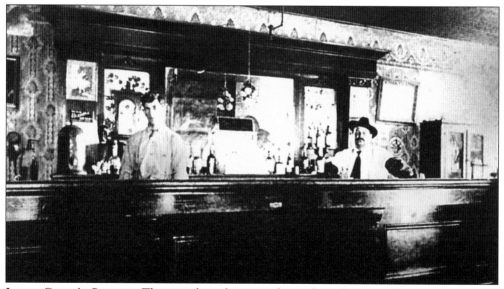

JACOB GALLE'S SALOON. This popular saloon was located on the east side of Broadway just north of Jackson Street. Patrons would gather to talk, conduct business, and play cards.

GRANT'S AUDITORIUM. This building's history is quite unusual due to the fact it was once located at the northwest corner of Park Street and Lincoln Avenue and was home to the Beulah Methodist Episcopal Church. In 1904, the building was purchased by A. G. Grant and moved east of the railroad tracks on the south side of Park Street. Known as Grant's Auditorium, the building was used as a theater, skating rink, and dance hall. It was razed in 2003. (Courtesy of Earl Nicholson.)

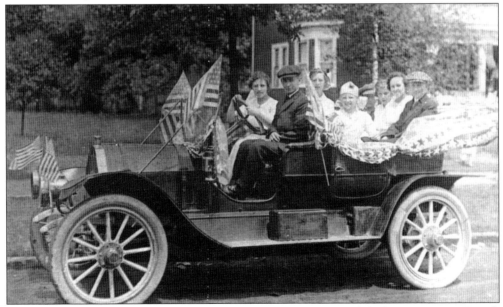

SHOVER FAMILY, C. 1910. The Shover family dressed up its automobile for Grove City's Fourth of July parade. Family members seen here are, from left to right, Ava Shover, George Shover, Aleta Shover, Melle Shover, Ralph Shover, Madeline Shover, Lulu Shover, and unidentified. The house behind them is the Jenkins residence.

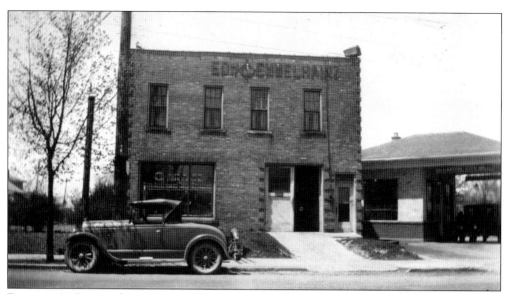

BETHARD'S GARAGE/EMMELHAINZ BUILDING. The Emmelhainz Building has served as the location for many businesses over the years. In this photograph, Bethard's Garage can be seen on the left side. Studebakers were also sold from this building. To the right is the Texaco gas station on the corner of Broadway and Grove City Road. Today this is Nora's Coffee Corner.

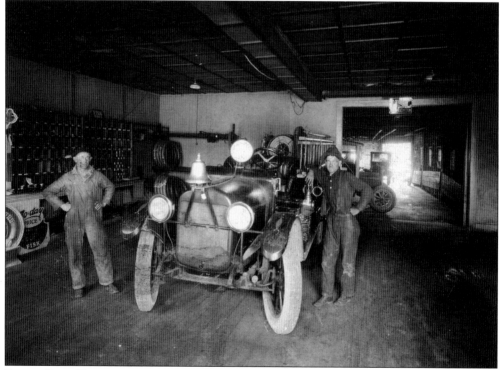

EARLY FIRE TRUCK, C. 1920. Grove City's all-volunteer fire department started in 1894 with a "barrel on wheels." This fire truck from 1920 was stored in the Emmelhainz Building. By the early 1940s, the Grove City Fire Department had joined with the Jackson Township Fire Department.

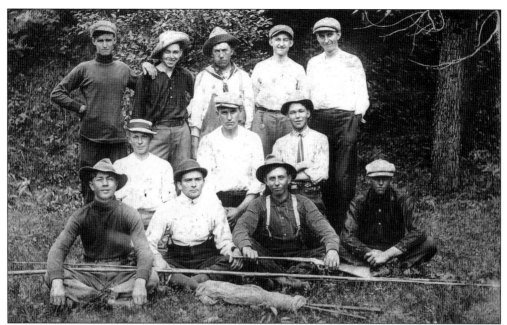

YOUNG MEN'S HUNTING CLUB, 1912. Area young men could sharpen their hunting skills by joining the Young Men's Hunting Club. Members are, from left to right, (first row) Edgar Haughn, Ollie Witteman, Carl Rensch, and Otto Landes; (second row) Bill Willing and two unidentified; (third row) Earl Landes, John Mueller, unidentified, Clarence Grossman, and Carl Graul.

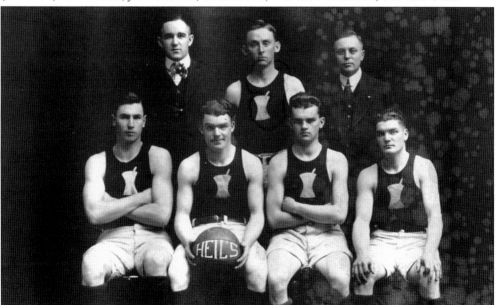

HEIL'S BASKETBALL TEAM, C. 1915. These young men made up a semiprofessional basketball team sponsored by Heil's Drug Store. The team includes, from left to right, (first row) Armond White, Glenn Hoddy, Lawrence Hoddy, and unidentified; (second row) Carl Davis, Orin Breckenridge, and D. Heil, sponsor and druggist. Breckenridge would later become Grove City's mayor, postmaster, and school superintendent. White would become track veterinarian at Beulah Park for 50 years.

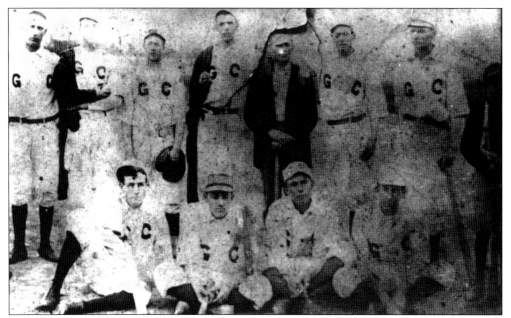

GROVE CITY BASEBALL TEAM, 1898. This semiprofessional team played at Beulah Park. Many of the small towns, including Harrisburg, had baseball teams that traveled the area playing for the love of the game.

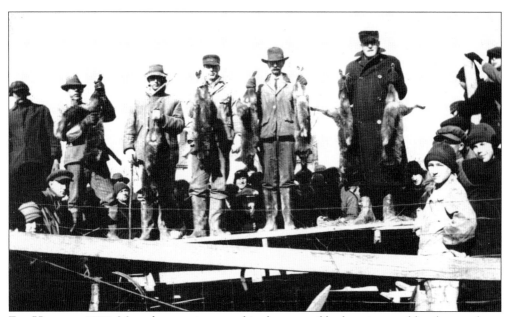

FOX HUNT, C. 1920. Men who were interested in the sport of fox hunting would gather at a large farm and form, on foot, a very large circle carrying their loaded shotguns. Participants walked slowly to tighten the circle until all hunters were in sight. Almost everyone who participated claimed one fox.

NORTH BROADWAY, C. 1924. This land on the east side of Broadway, just north of town, would become the site of the Franklin Kennel Club in 1926. The track served greyhound racing fans for only two years before the state halted the sport. It would open again in the summer of 1934 for five weeks before closing for good. The site is now the home of Our Lady of Perpetual Help Church.

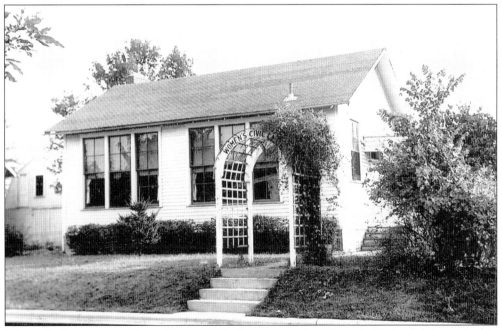

WOMEN'S COMMUNITY/CIVIC CLUB, 1929. Two groups, the Women's Civic Club (organized in 1916) and the Women's Community Club (organized in 1917), have donated numerous resources to the community. The two clubs joined to buy and maintain this building on Civic Place two years after incorporating in 1927. The building still stands.

GROVE CITY LIBRARY, 1930S. The library began in 1891 as individuals brought their private collections of books to Harsh's Drug Store for residents to share. It disbanded, and the Women's Civic Club established a reading room in the First National Bank in 1917. In 1923, the women moved the collection to this building at the corner of Broadway and Civic Place. It would not be until 1954 that the Grove City Library would have its present home on Park Street.

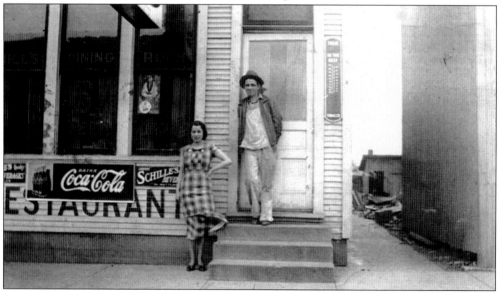

HILL'S DINING ROOM (1934–1947). Hill's restaurant was a popular establishment in downtown Grove City. Hill's had a beer and wine license and sold hamburger sandwiches for a nickel. The most expensive meal was a steak or chop dinner for 50¢. During World War II, owner Mamie Hill would sometimes borrow ration stamps from friends to have enough sugar and other items to stay in business. Pictured are Maye Miller and Russ Hill.

LIAR'S CLUB, C. 1950. The Liar's Club, a group of Grove City businessmen, met from the 1930s to the 1950s to share camaraderie and a meal. They are, from left to right, Pete Windsor, John Leach, Orin Breckenridge, John Smith, William Grossman, Marshall Kegg, Emmett Landes, Curtiz Kunz, Harold Underwood, Eldon Brown, Harold Mueller, Walter Thompson, Bill Albright, ? Hipple, Elvin Weygandt, Stanley Grooms, Russ Darnell, John Lewis, Otto Hensel, Bob Kropp, George Iftner, Raymond Graul, Rollie Haines, Howard Shover, Elmer Kunz, and Eddie Geyer.

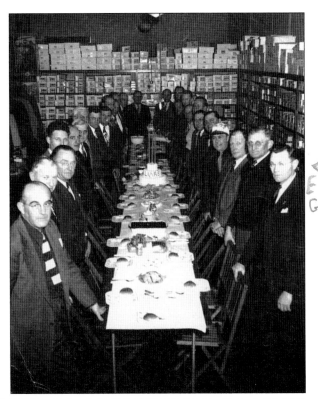

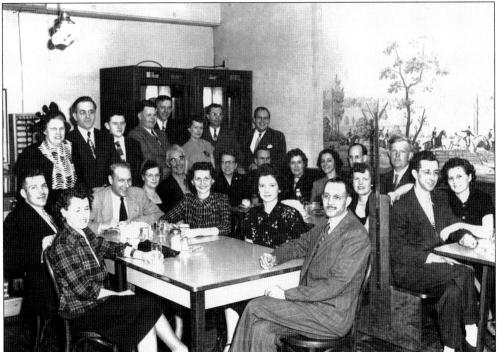

CAMERA CLUB, 1944. This group met at Dit Devault's restaurant on Broadway during World War II to socialize and talk about their common interest in photography.

BRECKENRIDGE SCHOOL OF DANCE AND MUSIC, 1937. Over two generations of music and dance students were taught by Martha "Mattie" Breckenridge from her home in Grove City. Breckenridge held a review each year featuring brightly costumed dancers who performed to music she played on the piano. Many of the musicians in the Grove City High School Band and Orchestra were taught by Breckenridge. The dancers in the image above are, from left to right, Patty Lyle, Lois Pfeil, Phyllis Neff, Betty Cain, Bonnie Washburn, Patsy Neff, Doris Edwards, Dorothy Stough, Jean Riebel, Geraldine Greggor, Patty Greggor, Maribel Breckenridge, and Patty Stough. Seen in the image below are, from left to right, Patty Stough, Lyle Wickliff, Patsy Neff, Bonnie Washburn, Lois Pfeil, Patty Lyle, Betty Cain, Phyllis Neff, Maribel Breckenridge, and Dorothy Stough.

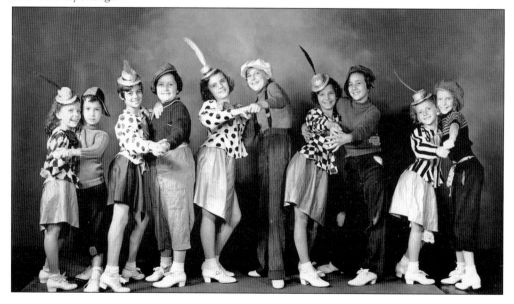

MUNICIPAL BUILDING. The Grove City Municipal Building held the offices of the mayor, city departments, police chief, jail, and mayor's court/council chambers. Pictured second from the right is Chief E. L. Evans with Capt. Ray Ruoff on the far right.

DUCKPIN TEAM, C. 1950. The Grove City Duck Pin Team met at the top floor of what was once Mulzer's Garage to practice its skills for local competition. Duckpin bowling was a popular sport in Grove City after World War II. Pictured are, from left to right, Elvin Weygandt, Vernon Fisher, Shorty Lambert, Doug Spangler, Roger Frank, and Joe White.

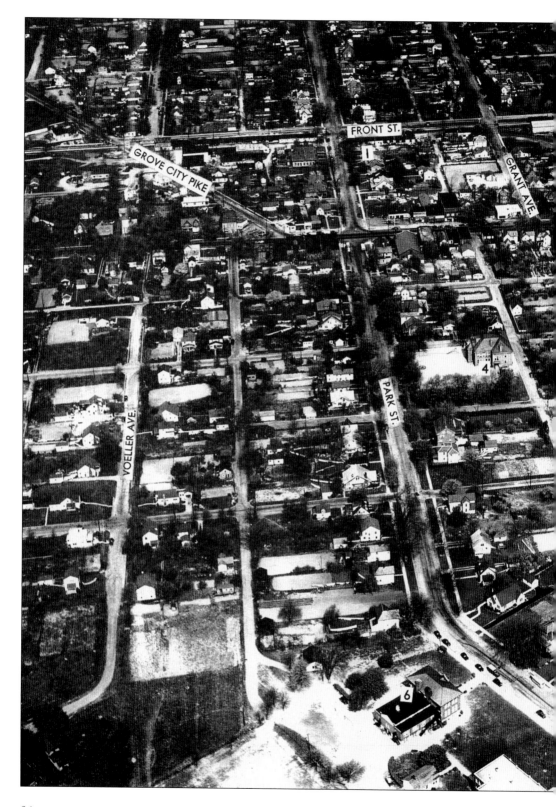

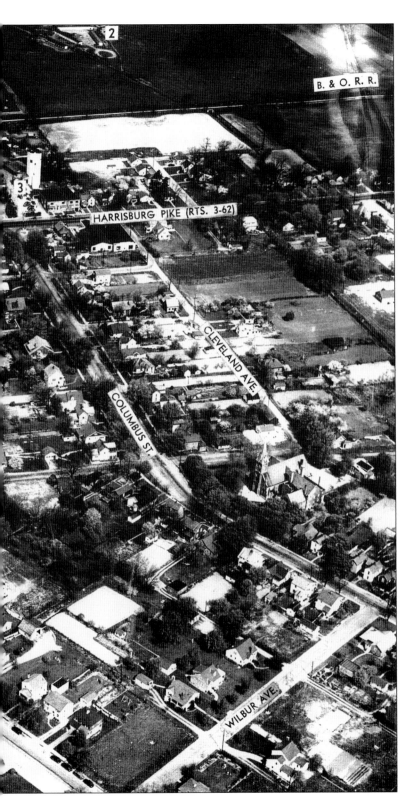

AERIAL VIEW, 1949. Grove City was transforming from a sleepy village into a growing town after World War II. This aerial shot shows Jackson Township-Grove City High School at the bottom middle of the photograph (No. 6). Note how both Columbus and Park Streets jog. This is due to the original lines of the Virginia Military Survey in this area of Jackson Township.

85

CHIEF RUMFIELD AND CHIEF EVANS. Jackson Township fire chief Olen Rumfield (right) and Grove City police chief E. L. Evans get together for a safety meeting for Grove City in this photograph of the two chiefs.

LOTZ HOME. This 17-room building on North Broadway at Lotz Drive was built around 1900. It became the El-Nor Inn from the 1920s until 1938 when it was purchased by Glen and Flossie Lotz. The house is constructed from tile manufactured at the Grove City Brick and Tile Factory behind St. John's Evangelical Lutheran Church. The Lotzes remodeled and used the building as a boardinghouse. Today it is the Village Merchant.

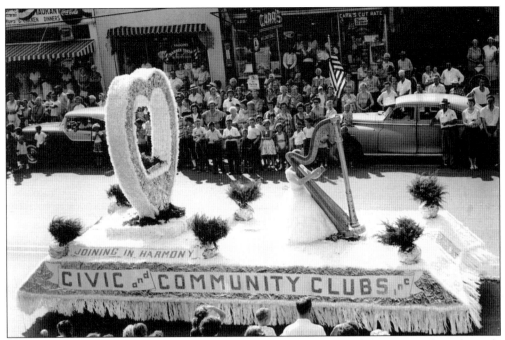

PARADE FLOAT, 1950S. Grove City has always loved its parades, and this picture from the early 1950s shows how everyone in town came out to view the floats, bands, and horses that have been part of the event since the early 1900s. At the top of the photograph are, from left to right, Goebbel's Restaurant, Gurney Vaughn's Barber Shop, and Carr's Drug Store.

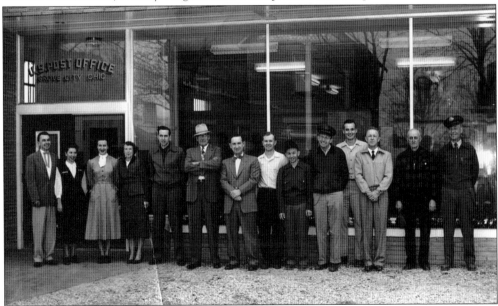

POST OFFICE. The Grove City Post Office moved to a new location on Grant Avenue in the early 1950s. At this time, the post office's three village carriers and two rural mail distributors served 12,000 patrons. Pictured are, from left to right, Emmett Todd, Miriam Todd, Charlotte Mueller, Rose Kennedy, John Temple, Cletus Ralston, Leonard Mueller, Donald Baumgartner, George Pruchnicki, Jake Stage, Arno Koehler, Eugene Haughn, Milton Mounts, and Tom Boos.

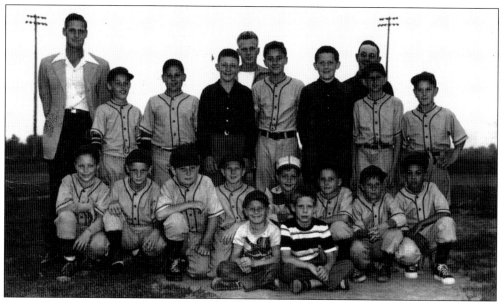

LITTLE LEAGUE, C. 1953. Little League baseball came to Grove City with the opening of the town's first community park, Windsor Park. Ball diamonds were originally constructed for the Babe Ruth League. Among the first two team sponsors were Broadway Cleaners and Grove City Lions Club, which still fund Little League teams to this day.

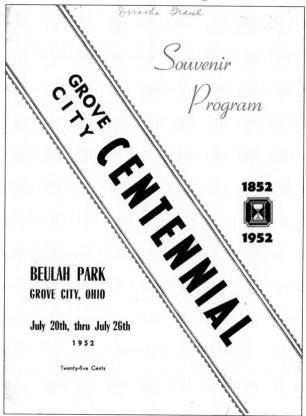

Souvenir Program

GROVE CITY CENTENNIAL

1852

1952

BEULAH PARK
GROVE CITY, OHIO

July 20th, thru July 26th
1952

Twenty-five Cents

GROVE CITY'S CENTENNIAL PROGRAM, 1952. Grove City celebrated its 100th anniversary with a weeklong series of events and a big downtown parade. The finale took place at Beulah Park where a "Centurama" was performed, including a "panorama of past achievements" and a "vision of the future." The commemorative program states, "We have shared in the collective effort to give our citizens a rekindled pride in their heritage of history."

Eight

COMMERCE

For its first 150 years, Grove City existed primarily to serve the needs of the local farmers and their families. The very first enterprises include a blacksmith, a hotel, and a tavern. William Breck, who had originally located to the area to farm, saw the vast potential of the settlement and became a businessman instead. He owned a general store, operated the gristmill and sawmill, became the town's first postmaster, and was in the process of building a new home and a hotel when he died.

A variety of merchants operated in the village during the 19th century, including several general and hardware stores, meat markets, shoe shops, harness and saddle shops, hotels, and a tin shop. At one time, there were at least six taverns in place, including a beer garden. Other businesses included gristmills and sawmills, brick and tile factories, a farmers' exchange, and an ashery, at which ashes were made into tallow soap. One of the major manufacturers in town was a canning factory that operated for four years before going bankrupt. Other smaller manufacturers included a cigar factory and a pump factory.

By the end of the 19th century and the beginning of the 20th century, businesses sprung up to serve the more leisurely demands of the villagers. These included a bowling alley, a photography studio, an ice-cream parlor, and a barbershop. The first funeral parlors began to appear during this time. A. G. Grant, Hugh Grant Sr.'s grandson, became Grove City's most successful businessman. He helped organize the first bank, the first fairground, the first bedroom community, and the first and only interurban, among many other enterprises. His Beulah Addition helped lure Columbus commuters to the area, and his interurban transported them back to Columbus to work. As Grove City became more connected to Columbus, the nature of commerce changed considerably as more consumers were willing to make the trip into Columbus to shop. Today, however, the pendulum has swung, and Grove City is again home to a wide variety of merchants.

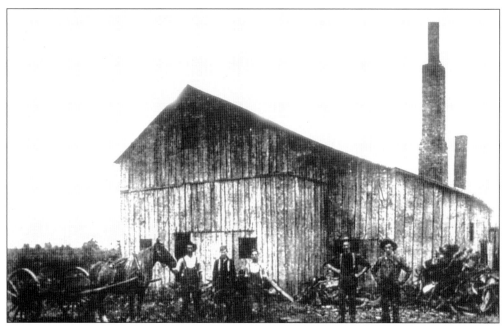

GROVE CITY BRICK AND TILE FACTORY. Grove City had several brick and tile mills. The first one was located east of the St. John's Evangelical Lutheran Church and was operated by William Breck. The final and longest-lasting plant was located behind the church. It started operations in 1888 and continued until about 1920. Shortage of the desired kind of clay in the area led to the closing of the business.

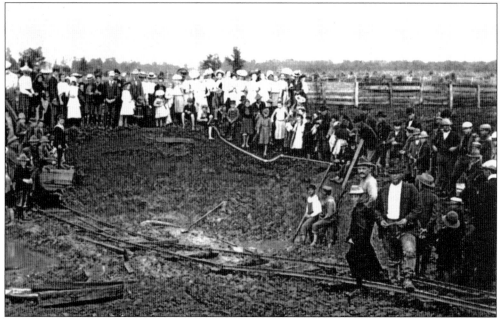

MASTODON BONES, C. 1890S. A mastodon skeleton was found in the tile factory pit in either 1888 or 1899, presumably during excavation. Another discovery near the same location was found in 1920. The tracks used by wagons to excavate the pit can be seen in this picture. The whereabouts of the bones today is a mystery.

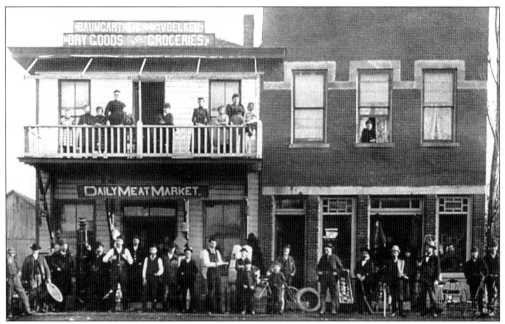

BAUMGARTNER AND VOELKEL BUILDINGS, 1881. This photograph shows two stores on the east side of Broadway before their destruction by fire. Flora Voelkel is seen leaning out the window. On the balcony are, from left to right, Fay Hoover, Ethel Hoover, Bessie Grant, Lib Baumgartner, Henry Baumgartner, Karl Wendt (with dog), Louise Corzilius, Flora Baumgartner, Emma Baumgartner, and Norma Baumgartner.

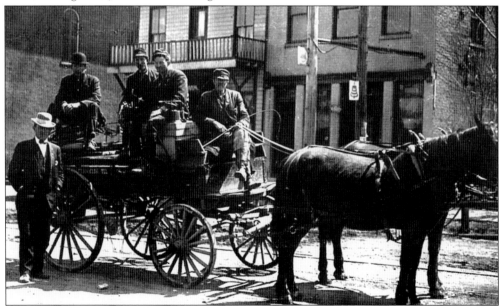

FRANKLIN TELEPHONE COMPANY, BEFORE 1912. A. G. Grant made the village's first long-distance telephone call in 1897 on a single toll line to Columbus. A line crew of the Franklin Telephone Company is shown here. The company was formed in 1898 to furnish telephone service from Grove City to Columbus. While the Columbus area had 6,706 telephones in 1904, Grove City only had 17 by the 1920s.

91

GROVE CITY GRAIN ELEVATORS, C. 1930S. The grain elevators were built shortly after the gristmill fire in 1921. The elevators were torn down in 2007, because they had fallen into disrepair. During the 1920s and 1930s, the exchange was one of the top producers in the state. The concrete elevators had a capacity of over 21,000 bushels of grain. A lumberyard was added in 1937.

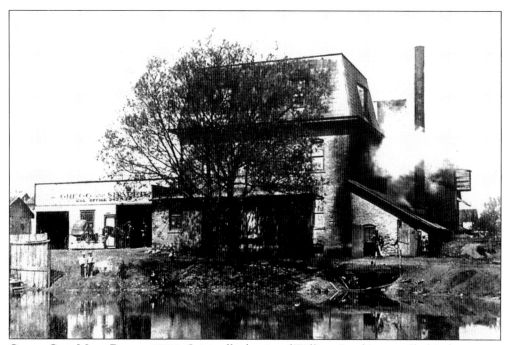

GROVE CITY MILL, BEFORE 1920. Originally the site of William Breck's sawmill, this three-story mill was destroyed by a fire in 1921. The pond in front was created when clay was removed for use at the tile factory. From 1880 to 1921, the pond was a popular location where residents gathered to swim, fish, and ice-skate. Mill Street Market is now located here.

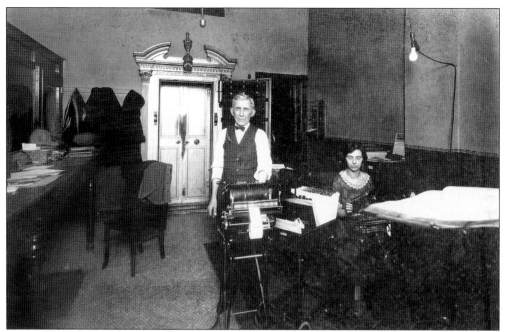

FIRST NATIONAL BANK, 1920. Otto Willert, bank director, is shown here with his daughter, Agnes, bank clerk, in the working area of the bank. The Women's Civic Club operated the early public library collection in the back room of the bank. Note the technology of the time: a crank telephone, an adding machine, a typewriter, and the ledger books that appear in the photograph.

FIRST NATIONAL BANK, C. 1914. The First National Bank was capitalized in 1903 with $25,000 around the same time as the Grove City Savings Bank was being organized. First National was robbed of $13,000 in 1920. The building at 3639 Broadway is now the Red Hat Box.

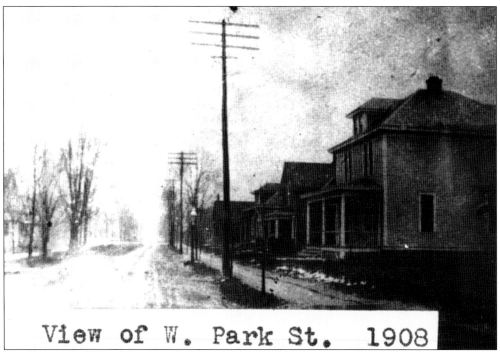

VIEW OF WEST PARK STREET, 1908. This view shows the telephone lines and the interurban lines running down Park Street to service the Beulah Addition and the fairgrounds at Beulah Park.

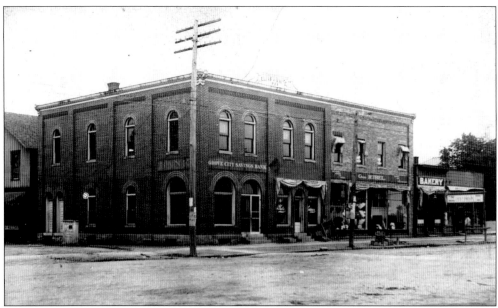

GROVE CITY SAVINGS BANK, C. 1923. In 1903, Grove City Savings Bank became the first bank to be organized in town. The bank, like many other enterprises, owed its beginning to A. G. Grant. Located in the heart of the business district in the Elias White Building, the bank sits at the southeast corner of Broadway and Park Street. The other businesses in the photograph include George Rubel's general store and a bakery.

WITTEMAN'S GROCERIES.
H. L. (Henry) Witteman was a butcher, farmer, and businessman whose store was located in the Elias White Building on the east side of Broadway. Witteman delivered his meats with this horse and wagon. Pictured are, from left to right, Wilhelmina, Hulda, Irma, and Henry Witteman. Eventually Henry left Grove City to set up a business in Newark. He returned several years later.

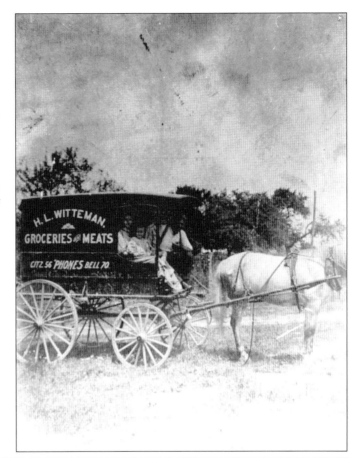

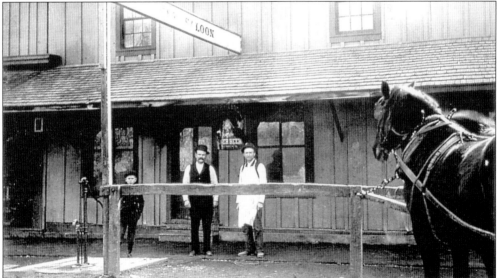

KUNZ SALOON, BEFORE 1901. The Fred Kunz Saloon was located on the east side of Broadway in a building that was torn down in 1902 and replaced by one built by Elias White. Pictured are, from left to right, Edward Hensel, Fred Kunz, and Edward Corzilius.

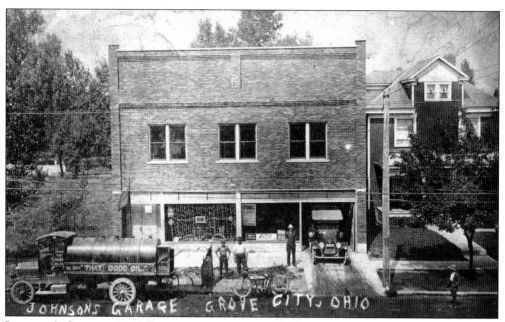

JOHNSON'S GARAGE, 3989 BROADWAY, C. 1919. Carl Johnson's garage, located on the west side of Broadway, sold and serviced Ford automobiles. This picture shows the Moore Oil Company truck on the left with a sign that says, "We Sell 'That Good Oil.'" Later the garage moved to the south side of East Park Street, and the building became Mulzer's Motor Sales, then Harley Motor Sales. After World War II, the building became the home of Grove City Hardware owned by Walter Leubben. The building still stands.

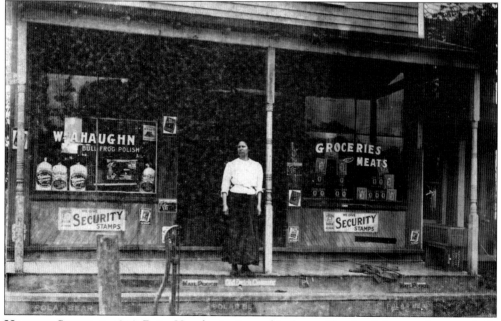

HAUGHN STORE, C. 1910. Daisy Haughn is pictured in front of her family's general store, which was located north of the Nichols-Buchholtz (now Davis) Building on the west side of Broadway. The site is near the present Mill Street Market (former Farmer's Exchange Building).

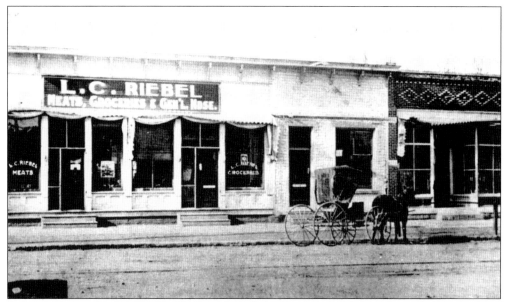

RIEBEL'S GROCERY STORE. L. C. (Louis) Riebel operated this business on the west side of Broadway and sold meats, groceries, and general merchandise. Riebel sold his business to Otto Grossman and moved out of town.

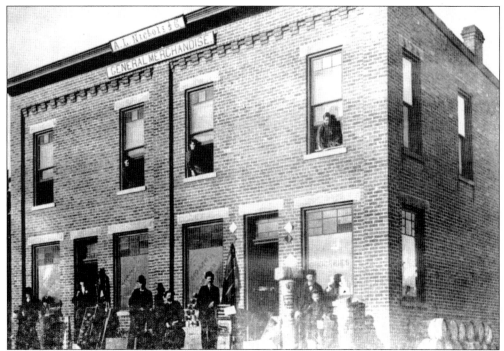

NICHOLS BUILDING, 3951–3955 BROADWAY, C. 1884. At the time, this building served as a general merchandise store. Notice the whiskey barrels stacked up on the side of the building and the women hanging out the windows.

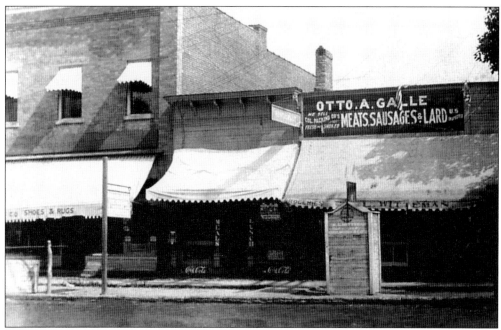

OTTO GALLE'S STORE. Otto Galle bought this store from H. L. (Henry) Witteman in 1915–1916. He kept the Witteman awning but changed the name to Otto A. Galle Meat, Sausages and Lard. The wooden hut in front by the street is an early gasoline pump.

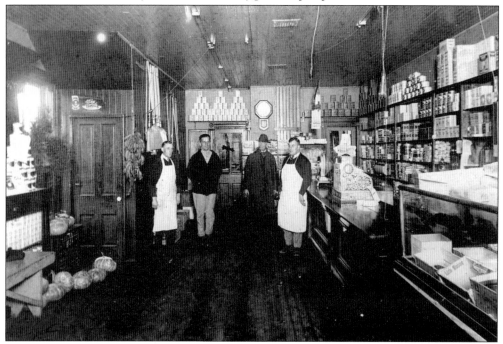

INTERIOR OF OTTO GALLE'S STORE. Galle moved his store from 4050 to 3990 Broadway, the present site of the Fifth-Third Bank. Patrons could purchase everything from brooms to bananas in the shop. Pictured are, from left to right, Clifford Phillips, Otto Riebel, unidentified, and Galle.

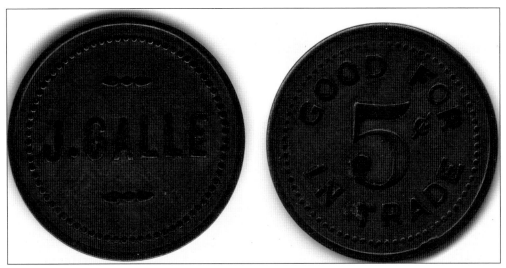

JAKE GALLE MONEY. Patrons of Jacob Galle's Saloon would often entertain themselves by spending evenings playing card games like poker and 7-Up. After the losers paid for the night's beverages, the bartender would pass out tokens, such as these in the photograph, that would be good for one free drink on a return visit.

DUNNICK'S ICE CREAM. Fremont and Emma Landes Dunnick built this soft-serve ice-cream shop on South Broadway in 1952 as one of Grove City's first fast-food restaurants. Shortly thereafter, the Grove City Roller Rink was built directly across the street, making it a hub for youth activities. This building is now Eats 'n Treats.

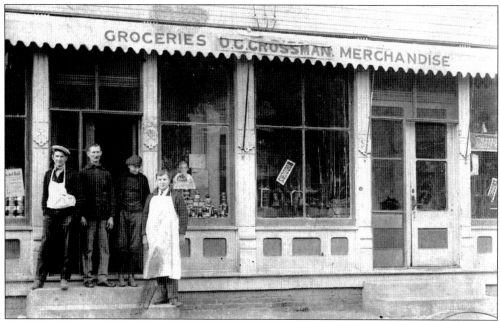

GROSSMAN'S GROCERIES. Otto Grossman bought L. C. Riebel's store when Riebel decided to move his business to another town. Grossman later built a store across the street on the east side of Broadway, which became the Red and White Store. As a young man, Grossman played with a local semiprofessional baseball team and was offered a contract with the Lima team in the old Central League. Pictured are, from left to right, Paul White, William Flach, Roy Grossman, and Otto Grossman.

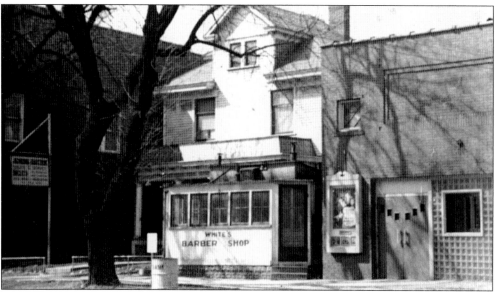

WHITE'S BARBER SHOP AND KINGDOM THEATER. This photograph shows White's Barber Shop (left), which was designed to look like a streetcar. The shop was on the west side of Broadway along the interurban line. To the right is the Kingdom Theater, which originally opened in 1915. Eventually the barbershop was moved (or torn down), and a new White's Barber Shop opened across the street. The theater is now Little Theater Off Broadway.

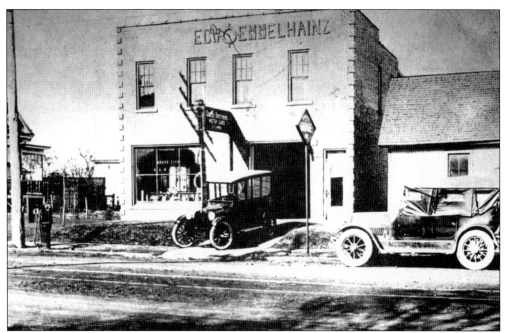

EMMELHAINZ BUILDING, C. 1920S. In its early years, the Emmelhainz Building served as both a motorcar sales showroom and the Grove City Garage. Studebakers were once sold here. Note the gas pump next to the telephone pole on the left-hand side of the picture. In the 1930s, the building was used by the local fire department. It is the current location of Nora's Coffee Corner.

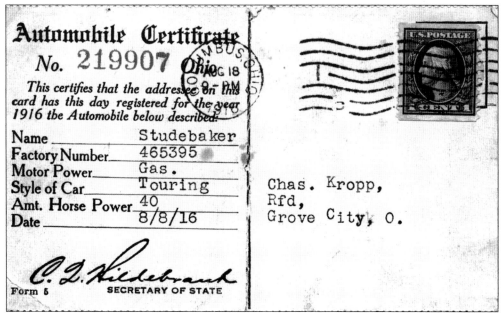

STUDEBAKER REGISTRATION, 1916. The Studebaker pictured above was presumably purchased at the Grove City Garage. Notice the details on the registration. The engine had 40 horsepower and was to be used for touring, a hugely popular adventure at the time. It was mailed to Charles Kropp, RFD (rural free delivery), Grove City—no other address needed.

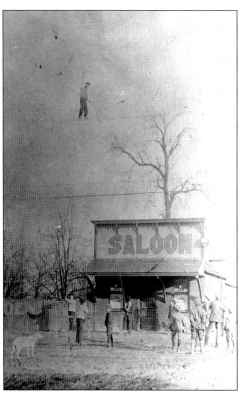

HIGH-WIRE MARKETING. This early photograph was taken at the "Saloon" (Frank Miller's) presumably as a marketing gimmick. Walking on the wire is Edwin Shilling. Another high-wire performer, Leo Earl, suffered serious injuries at the Grove City fairgrounds in the 1920s when he fell a distance of about 30 feet due to a faulty anchor wire.

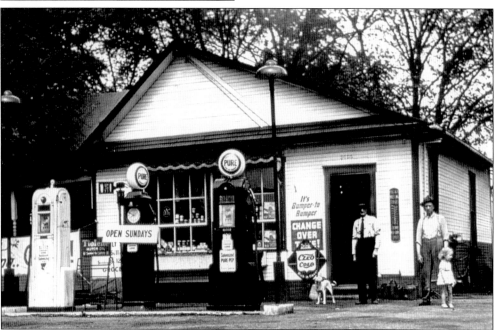

PURE OIL STATION, C. 1930. This building was built in 1916 and had originally been a bar owned by Ketterer and Flach called the Dew Drop Inn. It was located on North Broadway, just outside town. The establishment became a popular hangout after Grove City was voted dry. It was torn down in the mid-1950s.

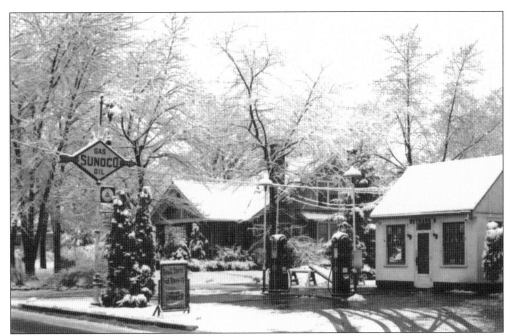

BETHARD'S. In the early to mid-1940s, there were seven service stations on Broadway. From north to south, they were Bethard's Sunoco, Bronner's Shell, Brink's Pure Oil, Marathon at Columbus Street, Standard Oil at Park Street, Texaco at Dutch Pike (Grove City Road), and Stough's on South Broadway.

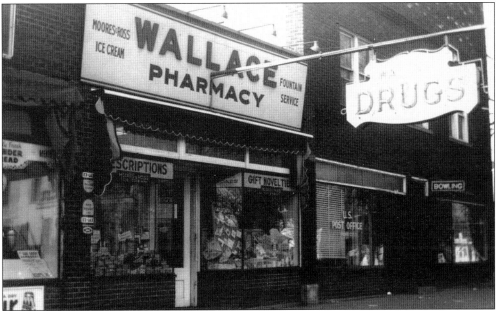

WALLACE PHARMACY, 1947. Pharmacist Fred Wallace and his wife, Eve, purchased Hanna's Drugs from Don Hanna on October 5, 1945. In 1953, Fred enlarged the store by incorporating Wade's Grocery next door. In December 1962, the store was sold to David Starkey and partner Kenneth Relyea, who changed the name to Kenstar Pharmacy. It is still in operation by a different owner.

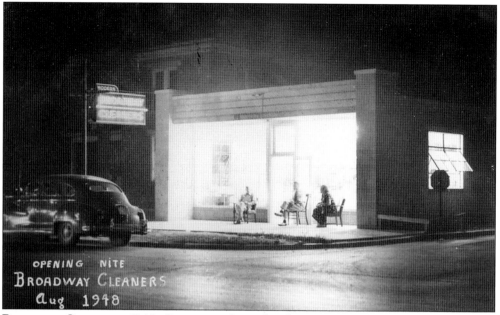

BROADWAY CLEANERS, 1948. Opening night at the cleaners is seen here. Joe White was the owner. A dry cleaning store still stands on this site.

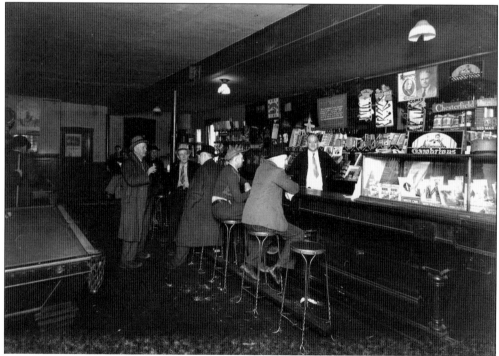

INSIDE ENDRES SALOON. Endres Saloon opened in 1905 in what was once the Voelkel Hotel and Saloon. It remains the oldest business building in Jackson Township. This photograph, taken during World War II, shows a picture of Pres. Franklin D. Roosevelt over the bar. The cherrywood bar where the patrons are sitting has been in the building since 1909. It is now Plank's on Broadway.

Nine

RACETRACKS

Grove City has been home to two racetracks and a neighbor to another. In 1889, when A. G. Grant created the Beulah Addition housing development on farmland west of the Columbus and Harrisburg Turnpike, he added a recreational park for village residents. Franklin County and Grove City fairs were held here intermittently until 1918, when the county fair relocated to Hilliard. Col. James M. Westwater bought and improved the grounds, which included a racetrack. In 1922, he sold his interest to the Capital City Racing Association.

The Capital City Racing Association then founded Ohio's first Thoroughbred racetrack at Beulah Park in 1923. It marketed the track's convenient access to Columbus via the interurban and direct paved roads. During the early 1930s, the racetrack was threatened with closure under the state's antigambling laws, but the track weathered this storm, only to stumble during the Depression. The track thrived during the 1940s and 1950s after pari-mutuel betting had been introduced. Throughout its history, Beulah Park instituted many changes, including altering the length of the track from a half mile to one mile, sharing its season with its harness racing neighbor, Scioto Downs, and adding telephone account wagering. In addition to horse racing, the park has hosted boxing matches, baseball games, motorcycle races, rock concerts, and, most recently, balloon festivals and fireworks on its premises.

In addition to Thoroughbred racing, Grove City became home to the popular sport of greyhound racing. During the 1920s, greyhound racing was all the rage throughout the United States, and racing ovals popped up everywhere. One such oval appeared in Grove City where Our Lady of Perpetual Help School now stands. Racing devotees were able to attend the "Sport of Kings" at Beulah Park in the afternoon and then take in the "Sport of Queens" at the greyhound oval in the evening. More than 4,000 fans were in attendance at some of the greyhound meets. State and local officials, however, were not as enamored with the sport as the general public. In 1931, they shut down the track and arrested its managers. A new kennel club tried to resurrect the track in 1934 but was unsuccessful.

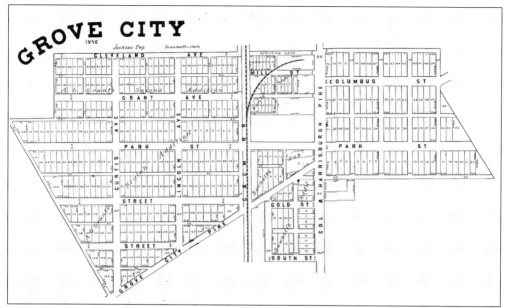

MAP OF BEULAH ADDITION, 1895. In 1889, A. G. Grant laid out town lots on 80 acres of land known as Grant's Beulah Addition, which he named after his daughter. Grant helped organize the local interurban, in part, to lure commuters to move to his new development.

BEULAH PARK GRANT STREET ENTRANCE, C. 1908. At the west end of Grant's Beulah Addition, land was set aside for a community park. Picnics, family reunions, and other social events were held at the park. The racetrack was laid out in 1895, and races were held first by the fair board and then later by Col. James Westwater. By 1923, the track became the site of Ohio's first Thoroughbred races. This entrance to Beulah Park on Grant Street shows the grandeur of the park and the grove of trees that were partly responsible for Grove City's name.

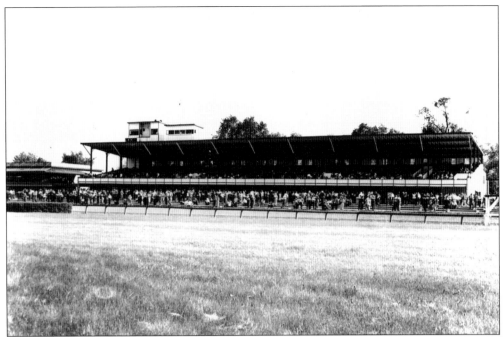

BEULAH PARK GRANDSTAND. The grandstand and grounds routinely could handle 7,000 spectators, and on certain holidays, up to 10,000 would be in attendance (some estimates put that as high as 20,000). Races started daily at 2:15 p.m. and were held rain or shine. Typically there were two racing sessions, spring and fall, each lasting several weeks.

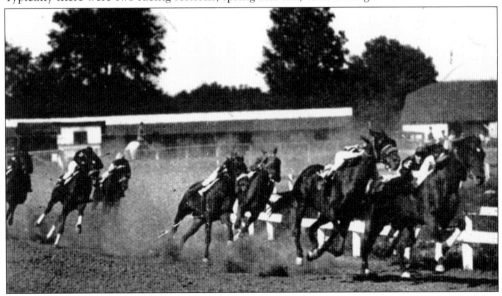

HEADING FOR THE HOME STRETCH, 1926. This shot captures the horses in full gallop as they head into the home stretch. Beulah Park was considered a prime plant and attracted horses from all around the country. In the 1930s, the purses totaled around $4,500. When Beulah Park's half-mile racetrack was built in September 1895, the construction costs were $2,000. The track was converted to a mile track in 1937 as part of a track improvement program costing $100,000. (Courtesy of the Columbus Metropolitan Library.)

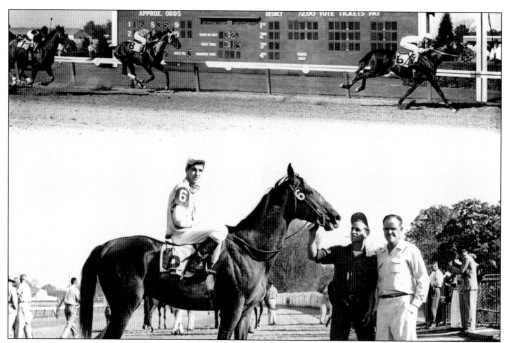

BILLIES MARK, C. 1952. Pictured here with Billies Mark is jockey N. Hart and trainer and owner J. V. Churches. Some of the world's best jockeys passed through Beulah Park, including Eddie Arcaro (who won more American Classic Races than any other jockey in history and was the only jockey to win the Triple Crown twice), Bill Shoemaker (one-time record holder for most wins), and Julie Crone (the only woman to win the Triple Crown).

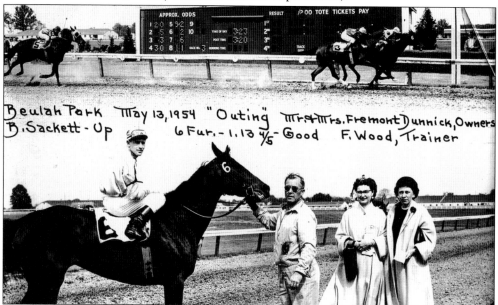

"OUTING," C. 1950. Fremont and Emma Landes Dunnick raced horses at Beulah Park for three decades. This horse, named Outing, won a six-furlong race in a time of 1:13. Fremont also trained horses in later years. Pictured are, from left to right, jockey B. Sackett, Fremont, Emma, and Rosemary Roach.

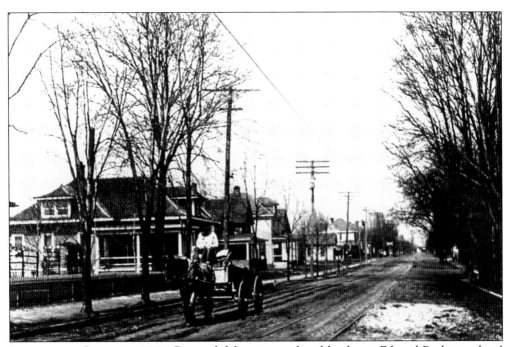

INTERURBAN LINE, C. 1920S. Pictured delivering coal and lumber is Edward Puckett, a local blacksmith. The interurban tracks were located in the middle of the street and served as a special extension of the interurban to bring the large crowds to the racetrack from Columbus.

VETERINARIAN DOC WHITE. Beulah Park always had a veterinarian on site, in addition to two doctors. The doctors got as much of a workout as the veterinarians. During the week of August 18, 1927, one spectator died of a heart attack brought on by a close race, and a jockey was thrown from his horse and killed. Dr. Armond B. "Doc" White served as the track veterinarian for 50 years. Aiding Doc White in the picture is Don Rowe, holding the horse.

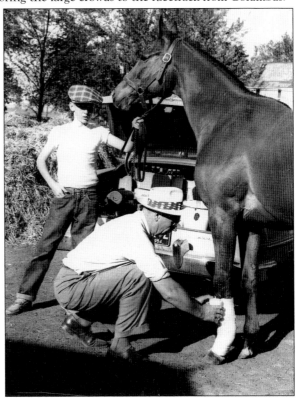

109

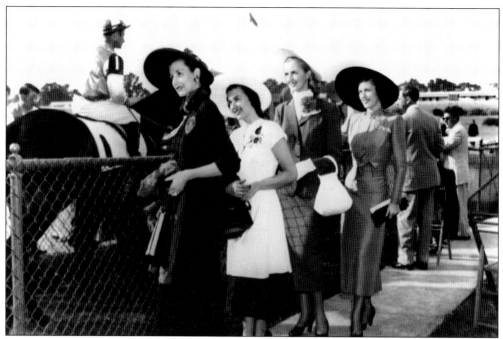

LADIES AT THE RACES. Beulah Park was the center of an active social scene, as many locals and visitors came to watch the races. Ladies' days, when women were admitted for free, were held on Mondays and Fridays and were particularly popular. As evident in this picture, a day at the races offered women an occasion to dress up in the afternoon.

MOTORING TO BEULAH PARK. To entice racing fans, the owners of Beulah Park touted the great roads to Grove City and its convenient location near Columbus. Traffic jams could be seen on all roads leading to the racetrack, but locals knew when and where to avoid the congestion. Sitting behind the wheel is Elvin Mulvaney.

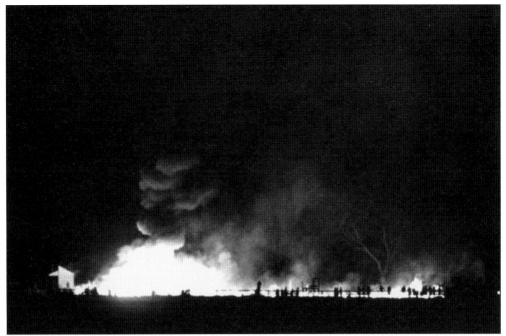

BEULAH PARK FIRE, 1945. This photograph shows a fire that struck one of the barns near West Park Street. The barn consisted of 42 stalls, only 4 of which were occupied at the time due to the recent close of the racing season. The horses were rescued, and the cause of the fire was never discovered.

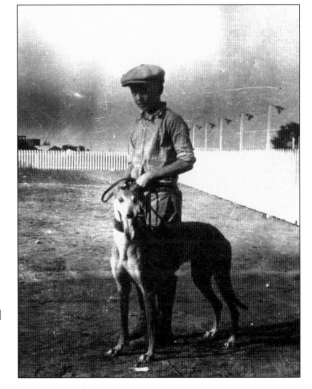

PAUL GROSSMAN AND GREYHOUND BILL CRUMP. Many local residents were involved in either racing or training the greyhounds, including Frank Weygandt (city councilman), Myron Haughn, Edward "Bill" Karnes, Martin "Petey" Baer, and Harold Windsor (councilman, newspaperman). The plant supported up to 440 greyhounds and 30 local workers, who helped with parking, policing, and other duties around the track.

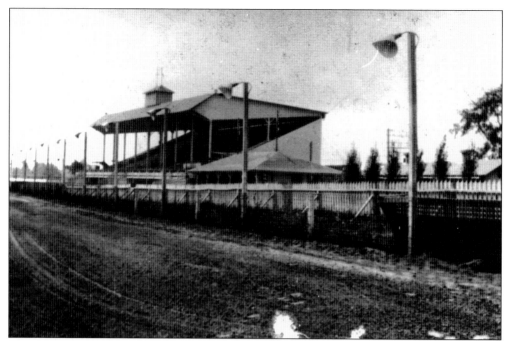

GREYHOUND GRANDSTAND, C. 1926. The track opened in September 1926 on a former large apple orchard owned by C. F. Neiswender. The greyhound racetrack thrived, in part, because racing fans could spend an afternoon watching the horses race and an evening watching the hounds race within the same small town.

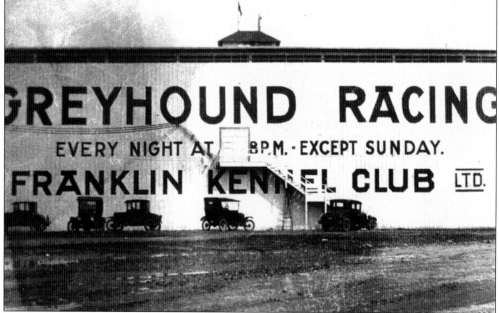

GRANDSTAND FRONT VIEW, C. 1926. Due to its enormous popularity, greyhound racing was big business for those involved. On Labor Day 1927, 3,000 fans attended the matinee program and 5,000 the evening one. While admission was normally $1, ladies' night was held three times per week and on Labor Day. The derby purse in the 1920s was $2,000.

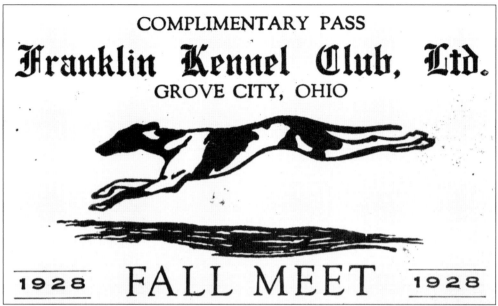

COMPLIMENTARY PASS

𝔉ranklin 𝔎ennel 𝔒lub, 𝔏td.

GROVE CITY, OHIO

1928 FALL MEET 1928

FRANKLIN KENNEL CLUB PASS, C. 1926. The Franklin Kennel Club sponsored local greyhound races for four- to six-week sessions from 1926 through 1928 and during a very brief session in 1931. A group of Columbus businessmen tried unsuccessfully to resurrect the racing in 1934. The plant remained dormant until it was transferred to the Columbus Catholic diocese, which built Our Lady of Perpetual Help Church and School on the premises.

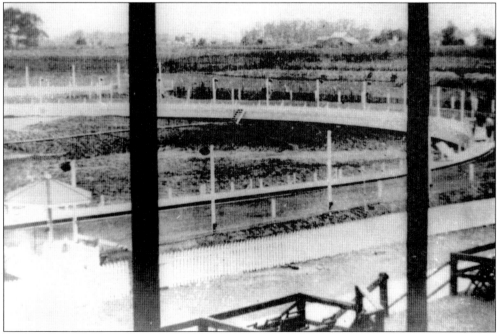

GREYHOUND OVAL, C. LATE 1920S. Eight races were usually held in the well-lit facility, starting at 8:00 p.m. The track was covered in cinder, sand, and gravel. The plant had a cement floor laid under the stand and a tote board built on the south side of the grandstand. Owners from kennels throughout the Midwest, including Chicago, participated at the track.

GREYHOUND RACING

SEE THE DOGS Chase the Electric Rabbit

WORLD'S NEWEST SPORT

8 RACES EVERY NIGHT **8**
8 P. M. — Except Sunday — 8 P. M.

Admission — $1.00

Take Interurban Cars at 3rd & Rich Sts.

FRANKLIN KENNEL CLUB, Ltd.
GROVE CITY, OHIO

ADVERTISEMENT FOR WORLD'S NEWEST SPORT, 1926. The track used a mechanical rabbit draped inside a fresh rabbit skin to entice the hounds around the track. An operator kept the rabbit about 20 feet in front of the pack. At a meet in June 1928, a greyhound did the seemingly impossible and caught the mechanical rabbit. Management called off the race and refunded all certificates.

GROVE CITY HIGH SCHOOL'S GREYHOUND LOGO. When greyhound racing was discontinued by the State of Ohio in 1928, racing enthusiasts launched a campaign to get it reinstated. A group of Columbus businessmen, in the hopes of garnering public support for the track, donated money to the Grove City High School athletic department, resulting in the school's greyhound logo and nickname.

Ten

PATRIOTISM

Given Grove City's start as part of the Virginia Military Lands district, it is not surprising that Grove City's patriotic roots run deep. Grove City citizens have been honorably serving their country since the late 18th century. At least four of its earliest residents fought in the Revolutionary War. These veterans include Samuel White, Joseph Hickman, Henry Shover, and John Hoover. Hoover, who served two different enlistments with the Pennsylvania Militia, is the only Revolutionary War veteran buried in Grove City. White, while fighting with the Virginia Militia, is reported to have been scalped at Stony Point and left for dead. Another early settler, Jonas Orders, served with Gen. "Mad Anthony" Wayne during the battles with Native Americans for control of the Northwest Territory.

Grove City's dedication to service continued into the 19th century, when several local men volunteered during the War of 1812, including John Hoover's son Peter and Hugh Grant Sr.'s son Jacob. Both men died from service-related illnesses. Other veterans of this war were Robert, James, and Joseph Breckenridge, William Baumgartner, Solomon Borror, and William Brown. During the Civil War, approximately 240 men from the Jackson Township area saw action and more than 30 died. Jonas Orders II, Jonas Orders's grandson, fought with Gen. William Sherman and was present for Confederate general Joseph E. Johnston's surrender in North Carolina during the waning days of the war.

The 20th century would also see a deep patriotic commitment from local residents, including many German Americans who, despite the anti-German sentiment of the time, fought during World War I. World War II saw Grove City's greatest generation answer the call to service. Local heroes include a Silver Star winner, a Distinguished Flying Cross honoree, and a prisoner of war. Grove City was fortunate in that only a few of its servicemen were killed during the war. The first casualty was Samuel Gemienhardt, who died on December 7, 1941, on the USS *Arizona* at Pearl Harbor. The Chambers family contributed five of its children (including one daughter) to the war effort. Area residents continued to serve during the Korean, Vietnam, Gulf, and Iraq conflicts. At home, Grove City citizens have proudly supported their country and their veterans with blood and bond drives, memorials, and parades.

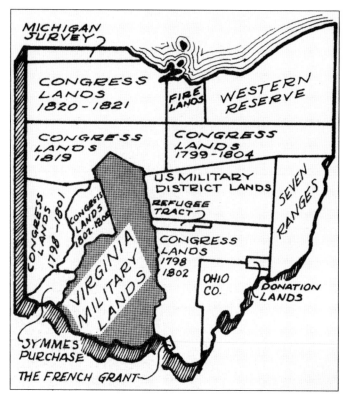

VIRGINIA MILITARY LANDS. This sketch depicts the Virginia Military Lands, which existed solely in central and southern Ohio and is unique for its metes and bounds survey system, which caused many headaches for property owners. Virginia agreed to cede its claims to the lands northwest of the Ohio River in return for land for its Revolutionary War soldiers. Each soldier was given a certain number of acres, depending on his rank. Many Virginians, not wanting to relocate to Ohio, sold their land to speculators. (Courtesy of Earl Nicholson).

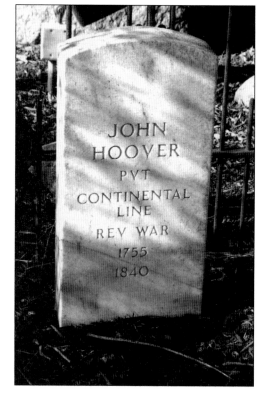

REVOLUTIONARY WAR VETERAN JOHN HOOVER'S GRAVE. John Hoover, a Pennsylvania native, served with Gen. George Washington when he retreated through New Jersey and when he crossed the Delaware River and fought in the Battles of Trenton and Princeton. In 1807, Hoover purchased 200 acres in the area that is now Gantz Road. Hoover is the only Revolutionary War veteran buried in Grove City.

JONAS ORDERS II, CIVIL WAR VETERAN, 1865. From the time he enlisted in 1863 to the time he mustered out in 1865, Jonas Orders II saw heavy action with the 113th Volunteer Infantry. He fought in the Battle of Chickamauga, where he was wounded by shell fragments but was probably saved by his pocket watch. He was with Gen. William Sherman during his march to the sea and was present for the surrender of Confederate general Joseph E. Johnston's surrender in North Carolina, which occurred 17 days after Gen. Robert E. Lee's surrender at Appomattox and essentially helped sound the death knell for the Confederate army.

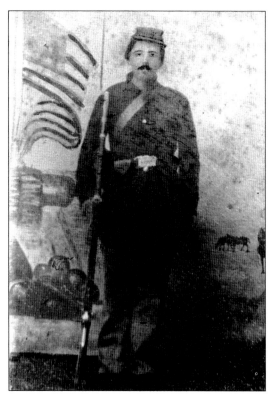

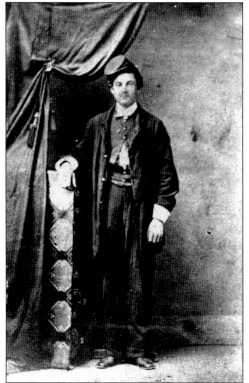

ELIAS WHITE, CIVIL WAR VETERAN, c. 1863. Elias White was born in 1844, one of 10 children of Jacob and Eliza White. In 1863, he served with the 88th Regiment of the Ohio Volunteer Infantry, Company H. This battalion became the First Battalion of the Governor's Guard and served at Camp Chase, which by 1865 held over 9,400 prisoners. White received a $12 monthly war pension due to his service-related illness.

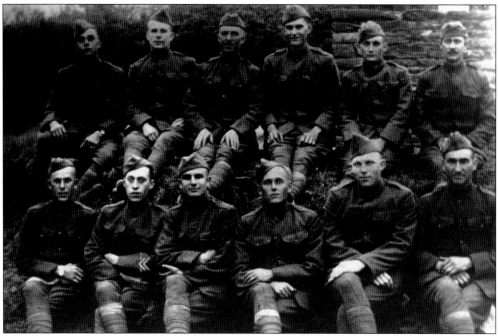

WORLD WAR I VETERANS, 1918. Grove City's doughboys included the 12 men in this photograph who served with the American Expeditionary Forces and fought at Meuse-Argonne in France, the largest American military operation during the war. Shown are, from left to right, (first row) Ed Hensel, Grover Davis, Pearl Gunderman, Henry Uhl, Guy Patterson, and Ben Trapp; (second row) Chris Zimmer, Frank Holland, Loren White, Clarence Graul, Elbert Dysart, and Frank Peterson.

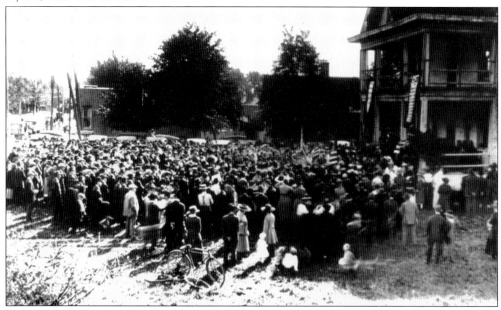

WAR BONDS, C. 1917. This bond sale was held outside the Woodland Hotel at 4009 Broadway, on the corner of Broadway and Park Street facing south. The building was torn down in the 1920s and is the current site of the Graeter's ice-cream parlor.

OUR BOYS

William Ranke	Clarence Grossman
Clarence J. Braun	Anton H. Baer
Edw. F. Geyer	Oscar W. Graul
Clarence L. Graul	John Wahl
John C. Krebs	Elmer P. Baer
Edw. C. Riebel	Otto Miller
Pearl A. Riebel	Lawrence F. Graul
Otto L. Riebel	Elmer Ray Jahn
Harold Brause	Lawrence Ranke
Fred W. Hopfe	Fred Priwer
Henry Uhl	Herbert A. Witteman
Edw. Theis	Sylvester A. Linder
Harry W. Kropp	George Henry Gramlich*

*Died in camp.

WORLD WAR I VETERANS, 1919. This is an invitation from the men's league at St. John's Evangelical Lutheran Church for the World War I veterans to be recognized for their service to their country. Twenty-six members of St. John's were honored for serving in the war.

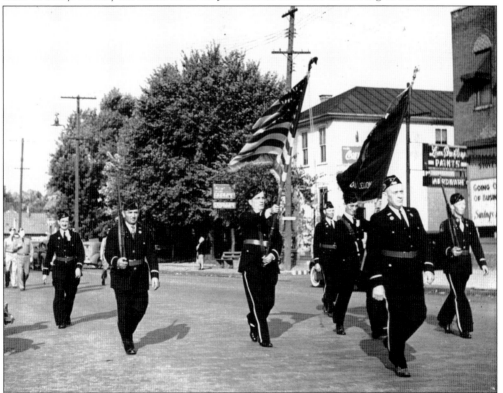

WORLD WAR I VETERANS IN PARADE, C. 1950. Pictured here are, from left to right, Bud White, Clarence Trapp, Otto Riebel, (carrying the American flag), Edward Geyer, Tony Baer, (carrying the other flag), Loring Kanode (commander), and George White.

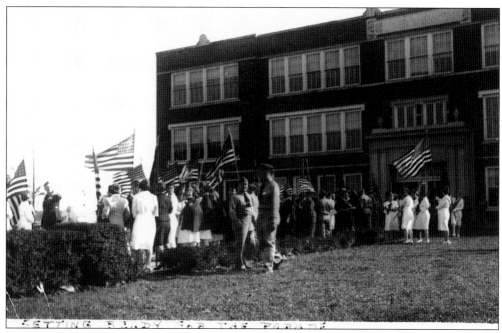

MEMORIAL CELEBRATION, 1941. Pictured here are the World War I veterans getting ready for the Memorial Day parade at Grove City High School, 3207 Park Street.

RICHARD NEFF, PRISONER OF WAR. Richard Neff joined the U.S. Army Air Force and became a tail gunner on a B-17 bomber. In April 1945, Neff was shot down and captured by the Germans. He escaped with the help of a local farmer and was rescued by the British. Among his medals are an Air Medal with an oak leaf cluster, an ETO (European Theater of Operation) Ribbon with five battle stars, and an MIA-POW Medal.

SAM DeVOSS, SILVER STAR, 1945.
Army staff sergeant Garfield A.
"Sam" DeVoss was awarded the
Silver Star for leading his men
through an icy pond in the face
of intense enemy fire. DeVoss
was a 1941 Grove City High
School graduate.

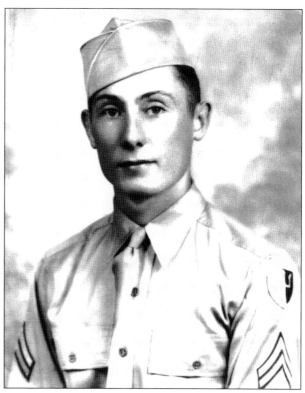

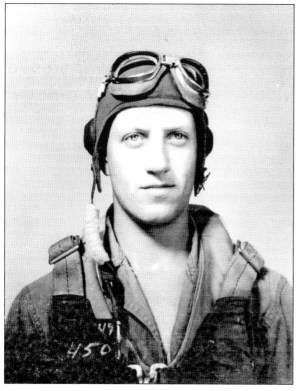

**EDWIN C. SMITH, DISTINGUISHED
FLYING CROSS, 1945.** Tech. Sgt.
Edwin C. Smith was a radio
operator and gunner on a B-24
during World War II. In 1945, Smith
was awarded the Distinguished
Flying Cross for extraordinary
achievement in combat while in
flight over the Pacific Ocean.

121

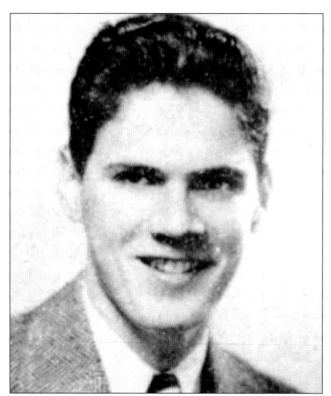

GEN. CHARLES DONNELLY JR., COMMANDER IN CHIEF (USAFE). In 1984, Charles Donnelly Jr., a 1946 graduate of Grove City High School, became commander in chief of the U.S. Air Forces in Europe and commander of Allied Air Forces, Central Europe.

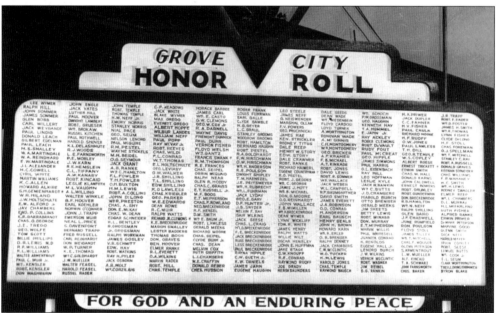

GROVE CITY HONOR ROLL, 1943. The Eesley-Zimmer Chapter of the Veterans of Foreign Wars erected this billboard on the northeast corner of Broadway and Park Street to show pride in those serving in the armed forces during World War II. Over 500 Grove City area men and women served in uniform through 1943. It is unknown how many served until the end of the war in 1945.

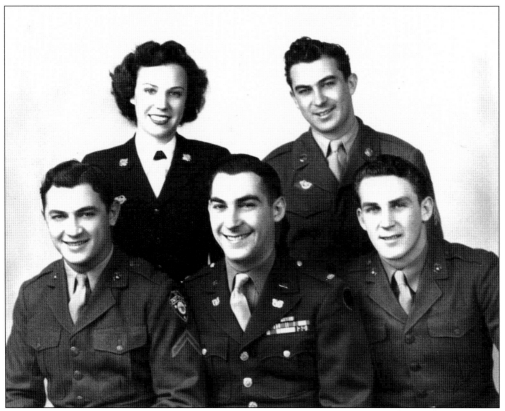

CHAMBERS FAMILY. These five children of widow Blanche Chambers (Dressel) all served in the armed forces during World War II. They are, from left to right, (first row) Jack Chambers (U.S. Marines), Lawrence Chambers (U.S. Army), and William Chambers (U.S. Marines); (second row) Jane Chambers Poston (U.S. Coast Guard SPAR) and Jay Chambers (U.S. Army).

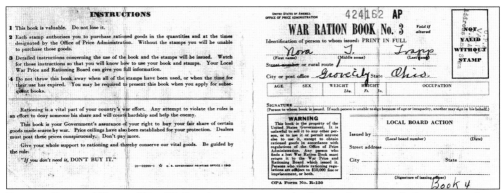

RATION BOOKS, WORLD WAR II. Supplies grew very tight during the war, and almost everything was rationed—gasoline, tires, sugar, meat, butter, even shoes. Families were asked to save grease so that gears in factories could be kept lubricated. Ration boards in towns doled out coupons stored in a ration book.

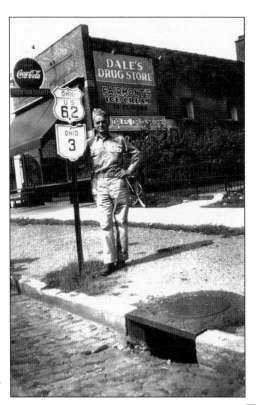

SOLDIER HOME ON LEAVE, C. 1943.
Clyde DeLong is standing along U.S. Route 62 through town. He is standing in front of Dale's Drug Store on Broadway, midway between Park Street and Grove City Road. The buildings on this block were torn down in 1989 to make room for city hall.

EARL NICHOLSON, KOREAN VETERAN.
Earl Nicholson served in the U.S. Navy during the Korean War on the USS *Hornet* in the Pacific. Nicholson would later serve eight years on Grove City Council as councilman-at-large. Nicholson, an artist who worked at Battelle Memorial Institute, has drawn and painted past scenes of Grove City for various local schools and brochures as well as two historic murals in downtown Grove City.

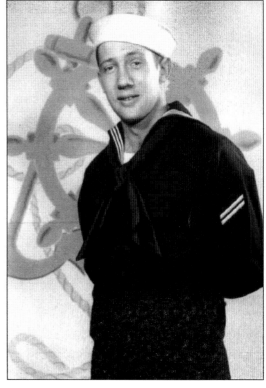

LOUIE EYERMAN, 1943. The
shortage of men due to the war
effort forced local employers
to hire boys to fill positions. In
this picture, Louie Eyerman,
a 15-year-old boy, works at
Bethard's Garage.

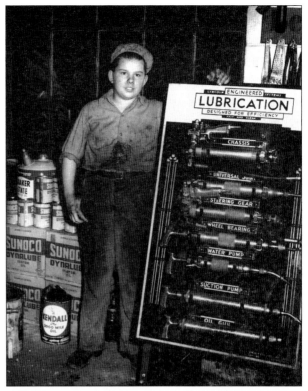

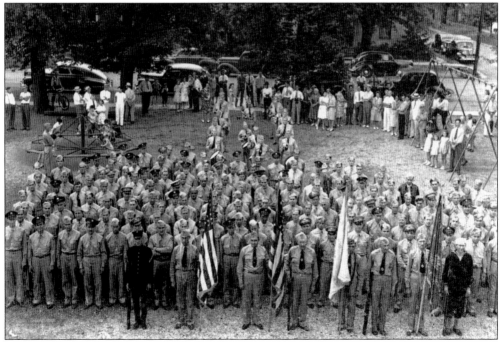

LOCKBOURNE BOYS, AUGUST 1942. Grove City played host to 180 soldiers stationed at the
Lockbourne Army Air Field, approximately 10 miles from Grove City. The base was opened in
1942 and provided basic pilot training and military support.

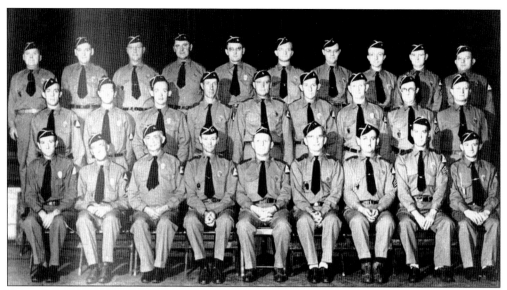

CIVILIAN POLICE, WORLD WAR II. The Grove City Auxiliary Police Platoon stood guard on the home front during the war. Included in the photograph are, from left to right, (first row) C. Helwagen, C. Strickler, J. Montgomery, E. Geyer, L. Kanode, O. Riebel, W. Weber, W. Hysell, and A. Schmerich; (second row) C. Compton, R. McKinley, R. Thomas, A. Borror, J. Ralston, T. Shipe, H. Borror, A. Sorvall, and B. Ehman; (third row) A. England, G. Iftner, O. Shover, R. Graul, R. Roberts, H. Sigman, L. Geyer, R. Grimes, J. Murray, and M. Compton.

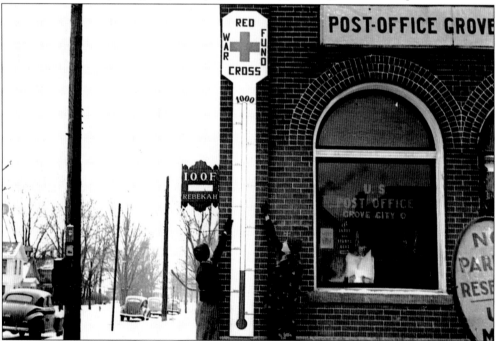

BLOOD DRIVE, JANUARY 1942. This photograph shows the Red Cross war fund thermometer, which was judiciously placed on the side of the village post office on the corner of Broadway and Park Street where residents were most likely to see it. The two young men in the picture are Jimmy Darnell (left) and Jerry Hawk.

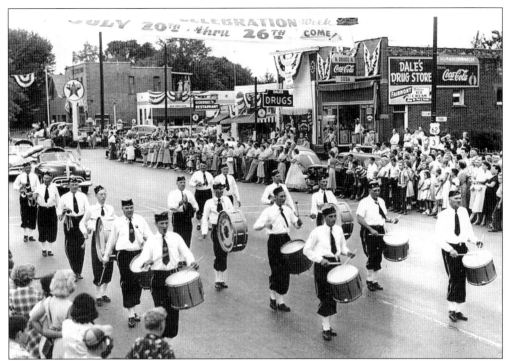

WORLD WAR I AND II VETERANS MARCH, 1952. Grove City's veterans marched in the centennial parade. Grove City leaders decided to celebrate the 100th anniversary of the year of William Breck's 1852 platting of the village. Citizens were encouraged to dress in period clothing.

STRINGTOWN ROAD FLAGS. The American Legion Paschall Post 164 and the City of Grove City have partnered since May 2004 to honor those serving in the military by flying these 44 flags on the fencing along the Stringtown Road bridge over the heavily traveled Interstate 71.

ACROSS AMERICA, PEOPLE ARE DISCOVERING SOMETHING WONDERFUL. *THEIR HERITAGE.*

Arcadia Publishing is the leading local history publisher in the United States. With more than 3,000 titles in print and hundreds of new titles released every year, Arcadia has extensive specialized experience chronicling the history of communities and celebrating America's hidden stories, bringing to life the people, places, and events from the past. To discover the history of other communities across the nation, please visit:

www.arcadiapublishing.com

Customized search tools allow you to find regional history books about the town where you grew up, the cities where your friends and family live, the town where your parents met, or even that retirement spot you've been dreaming about.